STOWE
THROUGH TIME
Anthony Meredith

Foreword by His Royal Highness The Prince of Wales

AMBERLEY PUBLISHING

For those whose time in Chatham House coincided with our own.

First published 2011

Amberley Publishing
The Hill, Stroud
Gloucestershire, GL5 4EP

www.amberley-books.com

Copyright © Anthony Meredith, 2011

The right of Anthony Meredith to be identified as the
Author of this work has been asserted in accordance
with the Copyrights, Designs and Patents Act 1988.

ISBN 978 1 4456 0486 2

British Library Cataloguing in Publication Data.
A catalogue record for this book is available from
the British Library.

Typeset in 9.5pt on 12pt Celeste.
Typesetting by Amberley Publishing.
Printed in the UK.

Foreword

CLARENCE HOUSE

Stowe is one of the finest illustrations of an idea which conquered the world. The Jardin Anglais was a microcosm; a world in which were afforded reminders, in small buildings picturesquely disposed, of the virtues which made it possible for people to live in the world together. To walk around the gardens of Stowe is to undertake a passage of discovery, and it is heartening that after a chequered history when, at times, it seemed all might be lost, it is now employed by Stowe School to help young people discover how to appreciate art and the landscape.

A legacy such as Stowe represents an abiding challenge to those responsible for it. Not just a fine house, but a fine park and garden, and a series of delicate temples and follies, it required for its understanding and preservation the combination of a number of different insights and skills. The story of how this place has survived, through triumph and decline, to be the treasure it is today is a gripping one, and Anthony Meredith deserves all our thanks for setting it out in this book.

It is a cause for celebration that Stowe remains, through the efforts of its past and present guardians, a beacon of civilized values still sending out its edifying message to the world, as it has from the beginning.

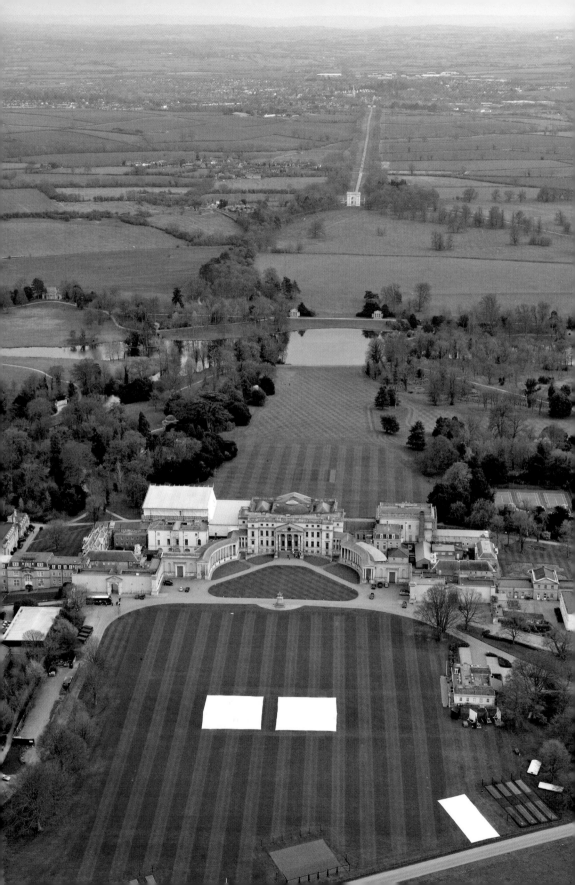

Introduction

Stowe lies amid sleepy Buckinghamshire farmland which has changed little over the years. Approached from the south, along a straight, switch-back avenue leading to a triumphal arch which would have gladdened the heart of any Roman emperor, it at once provokes a sense of disbelief. 'We seemed to be entering, by a sudden transition, a new yet old world,' wrote one first-time visitor, 'tunnelling into some dreamland canopied and guarded by heavy greenery and old stone.' That was seventy years ago, before disease ravaged the huge trees lining Stowe Avenue, but the sensation of entering a different, strangely unreal world remains. Stowe still exudes the mystery of past time. It is a perfect place for poetic imaginations, and, unsurprisingly, Alexander Pope was among its early devotees. Its 'spontaneous beauties', wrote Pope, made it 'a work to wonder at'. 'If anything under Paradise could set me beyond earthly objects, Stowe might do it.' He thought it 'as near to Elysium as English soil and climate will permit, for what art and opulence can command is here collected'. And Pope was writing some fifty years before its full, late eighteenth-century glory.

Our journey through time relates the glamorous eighteenth century to our own era and the partnership of three bodies from whose happily blended ambitions today's Stowe thrives: the school, founded in 1923; the National Trust, who took over care of the gardens in 1989; and the Stowe House Preservation Trust, an independent body formed in 1997. But we make a start in the thirteenth century with Stowe's oldest survivor, its church, which considerably predates the creators of the house and grounds, the Temple-Grenville family. Their 300 years of ownership began when John Temple, a prosperous sheep farmer, bought the manor in 1589, a year after the defeat of the Spanish Armada. And when his great-grandson tired of his old house and built himself something bigger, he set the stage for a spectacular golden age, over a hundred years of development (1697–1813) brought about by just three strong-minded owners.

The first two, Viscount Cobham and his nephew Earl Temple, spent much of their newly-acquired wealth on upgrading the house, embellishing it with gardens in the very latest taste, full of eye-catching temples, many of which mix classical antiquity with contemporary political comment. In the process the gardens moved from geometric formality to a revolutionary series of carefully planned, though seemingly natural, Arcadian vistas, inspired by the art of landscape painting; Stowe gradually developed into the grandest example of that delightful Georgian invention, the English Landscape Garden. And as the eighteenth century drew to an end, Earl Temple's nephew, the Marquess of Buckingham, added a final flourish to both house and grounds.

Alas, the good times didn't last. The Marquess' son and grandson (the 1st and 2nd Dukes of Buckingham and Chandos), lacking the income needed to match their vast commitments and spendthrift ways, presided over a decline and fall which culminated in the Great Sale of 1848, emptying the house. The 2nd Duke's public embarrassment, however, was posterity's gain. But for this spectacular financial crash, Stowe's landscape gardens would have gone the way of many others, destroyed by Victorian improvement schemes.

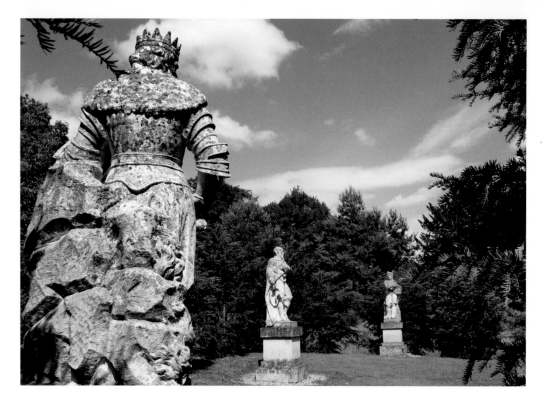

Three of six new characters at the Circle of Saxon Deities and one of two shepherds recently returned to the Circle of the Dancing Faun.

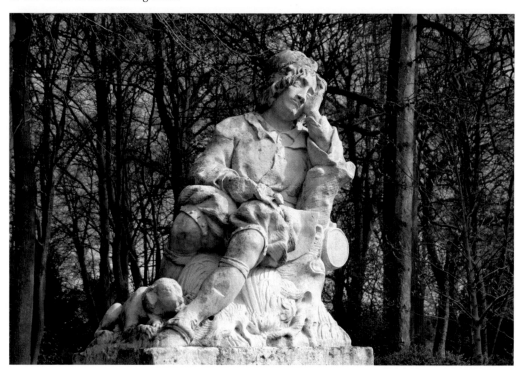

There followed a period of limited recovery. The house was reopened by the hard-working 3rd Duke, but his daughter Lady Kinloss found the commitments and demands of the place overwhelming. Large crowds gathered for the inevitable auction sale, which took place in 1921. Stowe seemed doomed, 'a melancholy relic of eighteenth-century taste' according to one commentator, only fit to be pulled down and redeveloped. Acquired by a businessman for £50,000, it was put up for sale again in 1922, when its break-up looked certain until the late arrival of an unexpected saviour, the Revd Percy Warrington, a west-country vicar whose passionate determination to establish new evangelical schools was matched by a flair for wheeling and dealing. Warrington (as secretary of the Martyrs Memorial and Church of England Trust) somehow acquired the house and 272 surrounding acres for a mere £30,000. Although only a few of the contents were salvaged and the empty shell required both running water and electricity, hopes were suddenly high. Such was the school's inspiring setting that it would surely soon be up there with the Etons and Harrows? Its charismatic first headmaster, John Fergusson Roxburgh, in bringing this ambition to fulfilment, adroitly used Stowe's greatest strength to maximum advantage. 'Make the most of beauty,' he urged the first batch of pupils. 'Look at it, wherever you find it, as if you might never see it again.'

The choice of the school's first architect, Clough Williams-Ellis, was equally auspicious – a young man who had been an articulate voice in the fight to save Stowe and was determined to alter the nation's philistine attitudes towards the built environment. His various schemes of development, though inhibited by lack of funds and the need for 30 miles of plumbing and electric wiring, respected the basic integrity of house and grounds, and his bold and colourful touch was very much in the spirit of the place. He is celebrated today at one of his creations, Chatham House, looking out in bronze towards that straight, switch-back avenue to the south, which had only been saved from the developers by his decisive intervention.

The school was soon making gallant efforts to tame the overgrown grounds and plug the many leaking roofs, and, early on, there was an exhilarating sense of achievement. By the 1950s, however, the responsibility was weighing more heavily. 'If the surviving temples were allowed to decay,' noted the school magazine in 1954, 'the loss would be irreparable. It is therefore a great event that the Minister of Works has agreed to recognize the garden temples as buildings of historic interest and to bear part of the cost of restoring and preserving them.' Grants from the Historic Buildings Council continued to be a merciful help, and in 1967 a covenant, drawn up with the National Trust, enabled their consultants to guide the restoration work. But the task was immense. Just between 1960 and 1980, for example, repair work was carried out on twenty-six garden buildings, the Temple of Concord and Victory alone costing a total of just under £1 million and the Corinthian Arch £600,000. In that period, too, 20,000 young trees were planted and six decayed eighteenth-century avenues reinstated. But, for all the school's efforts, it was essentially a losing battle, dilapidation continuing to outrun repairs. So there was great relief in 1989 when an anonymous donation of £1.8 million to the National Trust enabled it to take over responsibility for the gardens. 'Under the protection of the National Trust,' commented one delighted observer, 'Stowe can resume its place as one of the classic gardens of the western world.'

And so it has proved. A meticulous survey started things off, followed by a £10 million 5-year plan of restoration of some particularly vulnerable temples, the massive needs of Concord and Victory alone requiring £1.3 million. The 320,000 tons of silt removed from the Stowe waters was another early indication of intent. Twenty-one years on, those who knew the gardens in their 1989 guise marvel at all that has been (and continues to be) achieved by a huge ongoing programme of clearance and replanting, the opening up of vistas and original pathways, the steady restoration and conservation of garden buildings and the replacement of much lost statuary. All this (and much more) has been backed up by scholarly research. The result? A spectacular example of the English Landscape Garden re-emerging from Tennysonian romantic decadence.

These achievements were very soon putting into a new context the problems the school was still facing in the house, whose fabric over the years had needed constant expensive repairs. In the mid-1990s, therefore, the National Trust was approached, but, understandably, felt unable to add to its already heavy commitments. With the house now included on the World Monuments Fund's watch-list of endangered sites, a separate and totally independent Stowe House Preservation Trust was founded, leasing the mansion from the school and commencing a daunting fundraising operation for a six-phase programme of restoration. By 2008, the first two phases (costing a huge £15 million and involving both North and South Fronts) had been completed, and Stowe House, like a glamorous old film star, now basks joyfully in her state-of-the-art facelift. The third phase, currently reaching its conclusion, completes the work on the roofs and the south side of the house, and has made a start on the historic interiors.

The school, meanwhile, freed from its longstanding double responsibility, has worked with leading London architect Rick Mather to draft a twenty-year master plan to underpin a new development programme, the fruits of which are already impressively visible. Co-existing very happily with the demands of a world-famous heritage site, the school continues to offer a very special education, a modern version, indeed, of a concept which dates all the way back to that classical world so admired by Stowe's eighteenth-century grandees. 'Let our youth live in a healthful land,' wrote the Greek philosopher Plato, 'among beautiful sights and sounds, and absorb good from every side. And beauty, streaming from the fair works of art shall flow into eye and ear and insensibly draw the soul into likeness and sympathy with the beauty of Reason.'

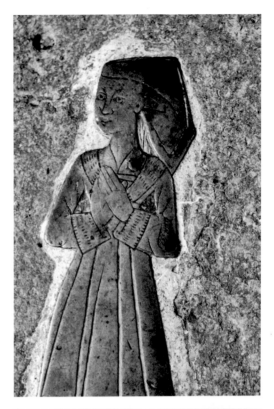

Medieval Times

Stowe Church, where the young Lancelot
'Capability' Brown married his sweetheart
Bridget and the grand Lord Cobham lies
unobtrusively buried, dates back to the
thirteenth century. A small brass memorial
(above) salutes Anna Saunders, no doubt
the wife of a Lord of the Manor prior to
the coming of the Temple-Grenvilles. She
died in 1454, just before the Wars of the
Roses. Below, the chancel where she was
buried (fourth floor-slab from the altar).
The charming little church, hidden in trees
at the eastern end of the house and full of
interesting connections with Stowe's past,
still serves the local community, its doors
open for worship every Sunday morning at
9.45 a.m.

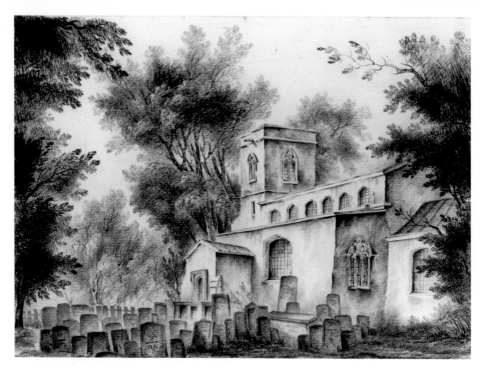

Medieval Times

The church's earliest surviving illustration (of 1805) shows it much as it would have been in the late fifteenth century (when the entrance porch was added), except for the removal (in the Marquess of Buckingham's time) of the tower's parapets and pinnacles. Below, a family pauses outside the porch after a Christening (in the early 1980s), much as 'Capability' Brown's would have done in the 1740s. The vicar, Jos Nicholl (second from right), was a history teacher, wartime commando and a Stowe pupil in the 1930s.

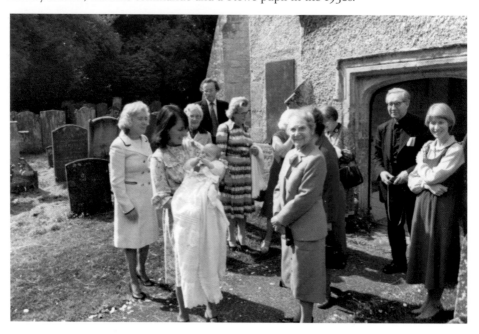

The Jacobean Era

Sir Peter Temple (1592–1653), great-grandson of the John Temple who had bought Stowe, lived in the old manor house, down the slope, once situated close to the church. The ear-ring and fine lace ruff suggest a prosperous lifestyle. Having made two profitable marriages, however, and having acquired wide parkland, the notoriously argumentative Sir Peter lost money in the Civil War and ended his days in debt. Below, another example of the family's wealth: the monument in the church to Sir Peter's sister, Martha, who at seventeen married Sir Thomas Penyston. Alas, the death of her two-month-old daughter and an ill-starred affair with the Earl of Dorset marred her brief life. She died from smallpox at only twenty-four.

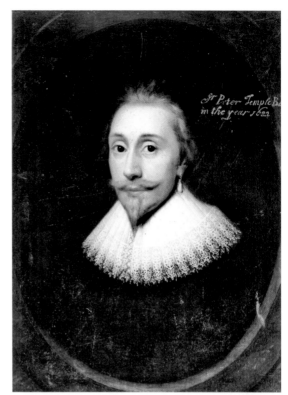

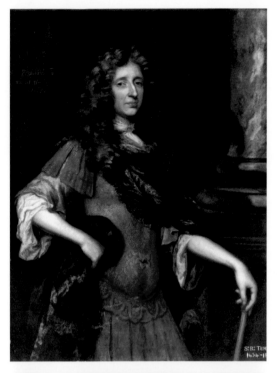

Sir Richard Temple (1634–97)

Sir Richard Temple was a long-serving MP for Buckingham, like his father Sir Peter. He sorted out the family's debts and, helped by his wife's large fortune, created today's Stowe House, or at least its central core. Designed by William Cleare, one of Christopher Wren's leading assistants, the thirty-eight-roomed house was of red brick, embellished with stone quoins on either wing. (The brick, which was later covered with fashionable stucco, briefly re-emerged during the restoration of the North Front by the Stowe House Preservation Trust in 2000–02.) The agreement made with the bricklayers and carpenters for this expensive new house still survives – it runs to twenty-four pages – but all may not have gone smoothly, for Sir Richard's unpredictability led to the nickname of 'the Stowe monster'.

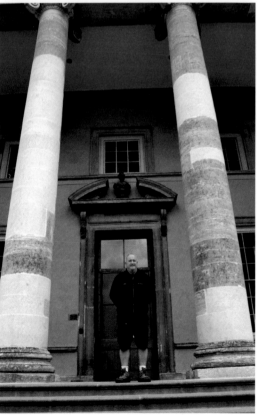

 Below, standing on the steps of the North Front's portico (erected after Sir Richard's time) is Steve Curley, manager of the school's gardens and sports facilities; his considerable brief includes seven cricket squares, nineteen cricket nets, eight pitches for rugby, five for football, three for lacrosse, an athletics track and a golf course. Behind him is the only immediately recognisable part of the original house, the main door with the distinctively curving pediment above it (visible on the drawing on p. 13). Inside the pediment is a bust of King William III (restored by the Stowe House Preservation Trust in 2002), a reminder that Sir Richard had supported the Glorious Revolution, the parliamentarian coup of 1688 which, in bringing William of Orange to the throne, supported Protestantism over Catholicism and laid the foundation for modern democracy by ending the absolute power of the monarchy. Much of Stowe quietly extols the family's strong political beliefs.

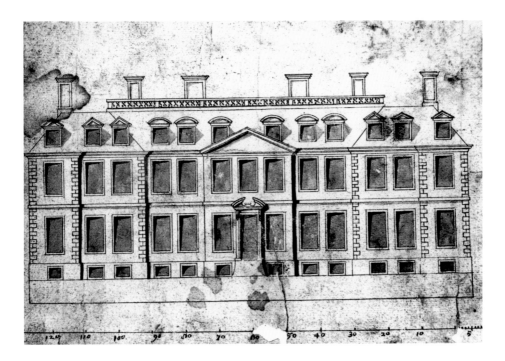

1680s

Above, William Cleare's design for the central block of Sir Richard Temple's red-brick house. Although it was soon to be altered radically by Lord Cobham, some similarity can be seen in the position of its windows – five either side of the central three. Below, the North Front in 1924, as the young school awaits the arrival of its first royal visitor – see p. 59 for more details. For all the pomp and show, money was tight and the North Front was badly weathered.

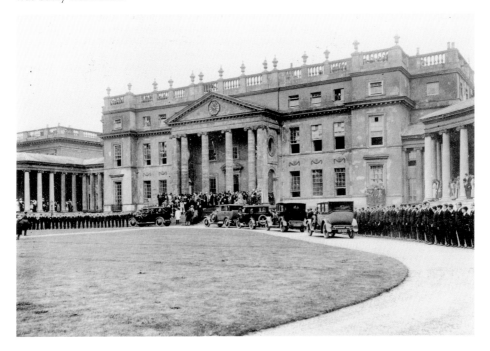

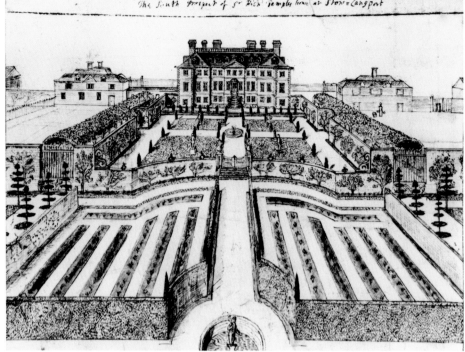

The South prospect of Sr Rich Temple house at Stow-Langport

1680s

The South Front in its earliest guise. Sir Richard's highly fashionable formal Dutch Garden, laid out on three terraces, was no doubt influenced by the glorious one which William III was planning for Kensington Palace. The house today, though much grander, still has low corridors connecting a central block to two wing pavilions. Below, the South Front 250 years later, during the Speech Day of 1933, which celebrated the school's tenth anniversary.

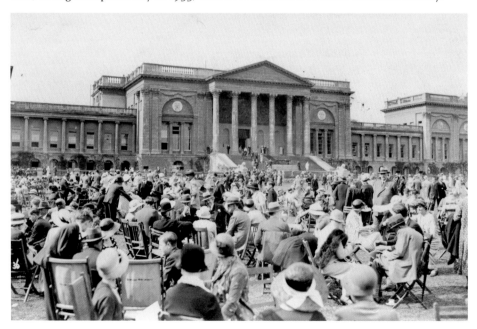

Lord Cobham (1675–1749)

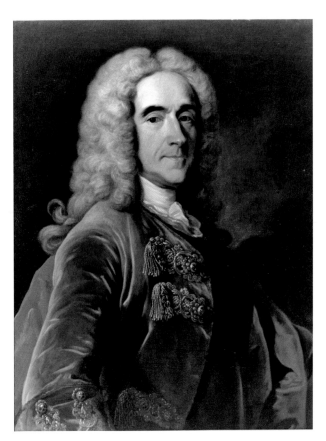

Sir Richard Temple's son, Lord Cobham, was an influential politician and successful soldier, whose marriage in 1715 to an heiress helped him undertake the first phase of his many improvement schemes, with Charles Bridgeman as chief garden designer and John Vanbrugh as leading architect. His new North Front owes much to Vanbrugh, though little of it can be seen today apart from the impressive portico. The arch (by William Kent) in the early screen wall (to the right of the trees) also survives. Cobham's lake only lasted 40 years, and the equestrian statue of King George I was moved closer to the house soon afterwards. Cobham had strongly supported the Hanoverian cause on the death of Queen Anne, and George I's gratitude brought him in due course a viscountcy.

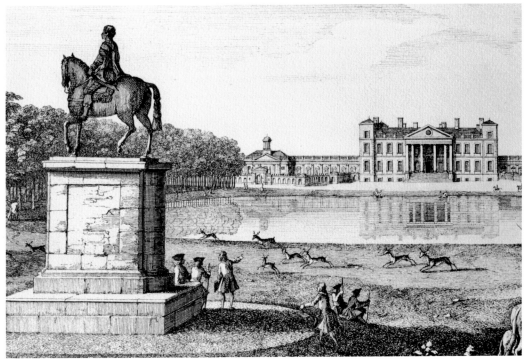

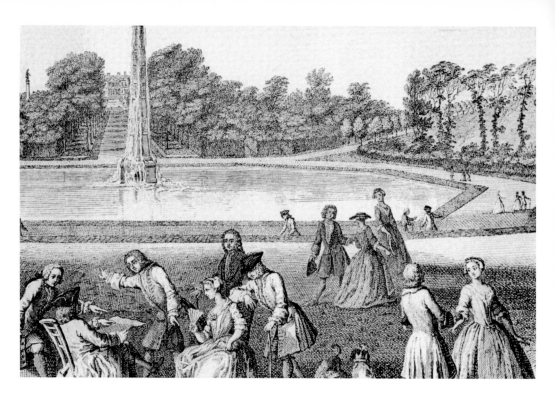

1720s

By the 1720s a modest fishpond had been turned into an elegant formal lake, the Octagon, which, as created by Bridgeman, really did have eight sides. Beyond the Octagon, a narrow avenue of double white poplars led up towards Cobham's much embellished house and the spacious new parterres which had replaced the flowery Dutch gardens. Below, Earl Temple's creation, as seen in 2000 but little changed since 1779: an open and steadily narrowing vista, carefully contrived to lead the eye to the South Front.

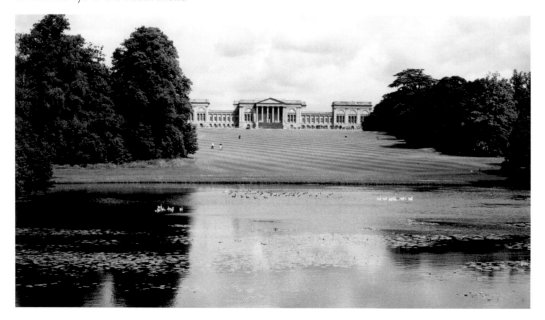

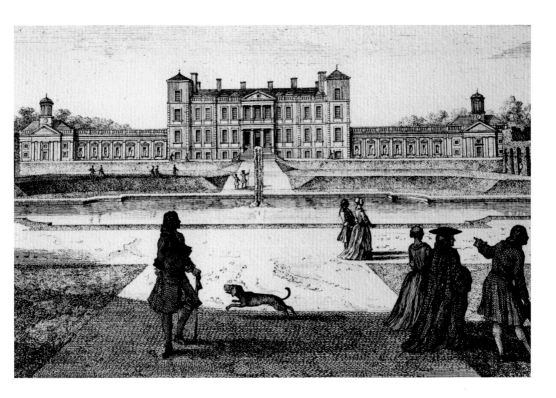

1720s

Cobham's new gardens, as the drawings by French artist Jacques Rigaud suggest, made an ideal setting for the poets and politicians who thronged the house. Alexander Pope knew it well. Statues, placed in niches cut into the surrounding clipped hedges (see p. 18), added an extra touch of dignity. So, too, the house's two-tiered central portico, designed by William Kent. Below, the same area on the last day of the summer term, 2011, obscured by scaffolding and other excitements.

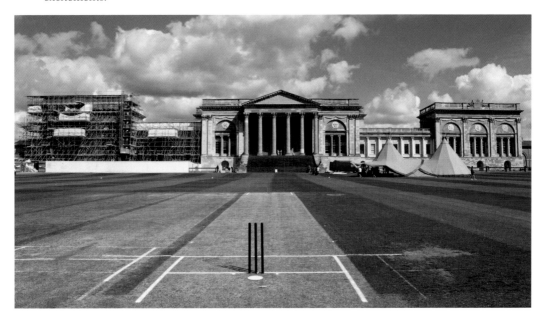

17

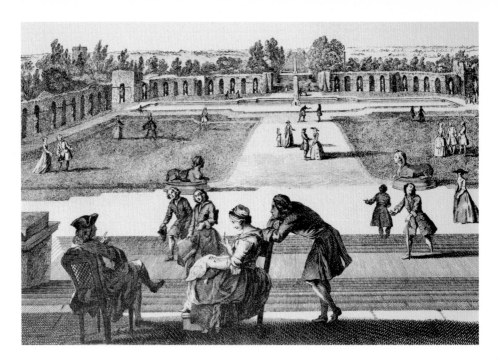

1720s

Rigaud's view of the parterre from the house includes Lord Cobham (seated left) and his nephew and heir, the tall and thin Earl Temple (leaning over Lady Cobham). Mounting the steps is the parterre's designer, Charles Bridgeman, new drawings in hand. In the far distance is the Octagon's 70-foot central obelisk. Below, no sign of parterres as teams set out on an architectural exploration during one of the school's Visual Education open days in the mid-1990s. (See p. 83)

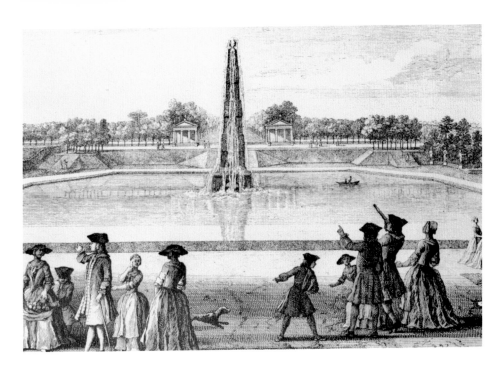

1720s

The Guglio (or obelisk) sometimes worked as a fountain, though the machinery was apparently unpredictable. Vanbrugh's two lake pavilions are in their original positions, very close to each other. The modern photograph, taken from halfway down the slope, shows that the pavilions were later moved further apart to frame the view of the Corinthian Arch. It also shows Russell Crowe being filmed (beside a carefully staged game of rugby) for the movie *Proof Of Life* (2000).

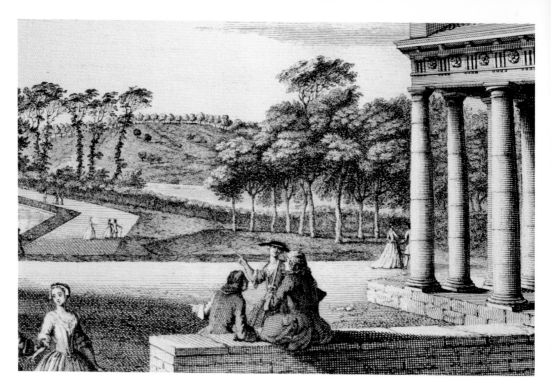

1720s

The view from one of Vanbrugh's Lake Pavilions to the Hawkwell Field shows the limited extent of Cobham's gardens at this time. The right-hand edge of the Octagon is just visible (left), and the lake is shortly to be naturalised and enlarged. Below, to the right of Lord Cobham's later eye-catcher, the Gothic Temple (1741), is an avenue of beeches, a gift to the school in 1941 and briefly featured in the James Bond film *The World Is Not Enough*.

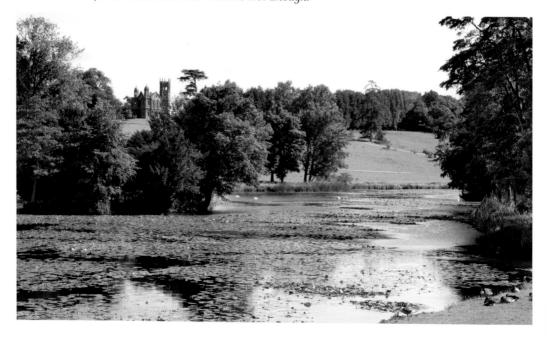

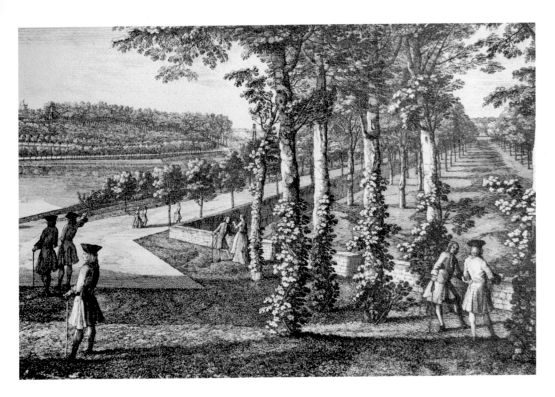

1720S

Bridgeman created straight carriage drives round the perimeter of his gardens, an accompanying ha-ha separating them from the park. Rigaud's view towards the lake pavilions from the Temple of Venus shows a low wall protecting the ha-ha's drop. Below, in the opposite direction, Capt. Mark Phillips competes in the 1984 Stowe Horse Trials. The avenue of young plane trees up which he is galloping had been planted eleven years earlier, to celebrate the school's 50th anniversary.

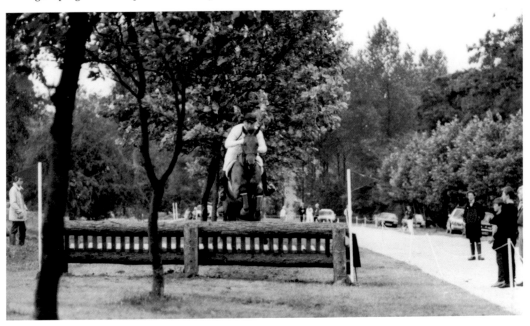

1730s

Cobham temporarily retired to Stowe in 1733, having fallen out with Prime Minister Walpole, and initiated a key period of garden development under William Kent, who had already been active around the new and formal lake west of the Octagon. Kent's secluded Hermitage, for example, looks across it to Vanbrugh's Rotondo. The lake was to be naturalised by Earl Temple, but 'naturalisation' was already on the Cobham-Kent agenda in the 1730s. The English Landscape Garden, *le jardin Anglais*, had arrived.

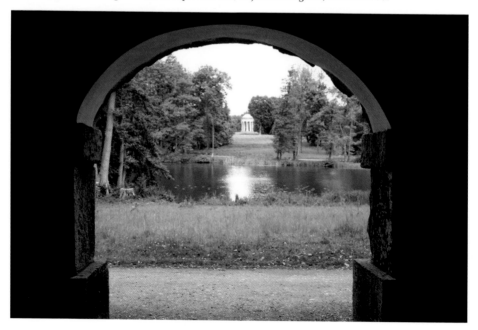

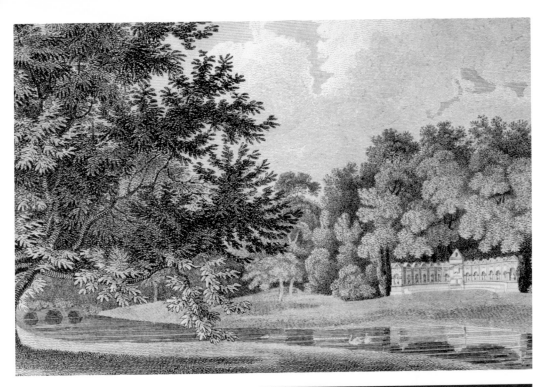

1730s

Kent's beautiful Elysian Fields, created on sloping banks above soporific waters, made Cobham's gardens famous, epitomising, as they did, the exciting new era of 'natural' landscaping, a striving to outdo paint and canvas by the reshaping of nature – with one idealised classical view leading on to another. They also had a political subtext, attacking Walpole's government and the court of George II, whose corruption and feebleness were satirised in three temples. That of the British Worthies (above) displays sixteen celebrities whose star quality was to put Walpole and his cronies to shame. Edward the Black Prince, for example, had scored many famous victories over the French. His inclusion was also a compliment to the current Prince of Wales, Frederick, who had fallen out with the King and joined Cobham's very active political cabal.

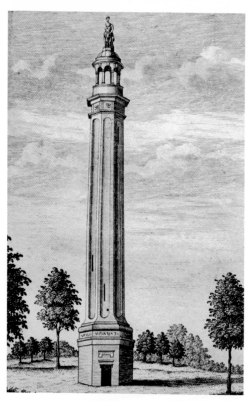

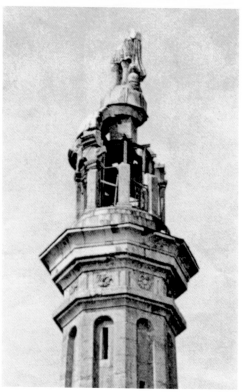

Cobham and Marlborough

Cobham always greatly valued the boost his military career had received from service as Colonel of a Regiment under the Duke of Marlborough. Participating in Marlborough's campaigns against Louis XIV's France, Cobham had proved himself a tough and accomplished young soldier, distinguishing himself in several of those famous battles which did so much to bring in a new era of national self-confidence, notably at Lille (the news of whose fall he personally delivered to Queen Anne), Malplaquet and Bouchain, though he was not present at Blenheim, which was shortly to give its name to the palace a grateful nation would bestow on his much-admired chief. Cobham's subsequent military career, though twice temporarily checked by political setbacks, hugely prospered and considerably enriched him. He ended up with the rank of Field Marshal.

Cobham would have known all about Blenheim and its problems, for Vanbrugh, its architect, was a fellow member of the Kit-Cat Club, that powerful gathering of Whig politicians and writers, formed initially to intrigue for the Hanoverian cause. Blenheim, naturally, exerted quite an influence on Cobham's Stowe. Both have entrance halls extolling their owner's military prowess. Both displayed elsewhere their owner's greatest campaigns with fine tapestries. And in 1746 Blenheim's Column of Victory, erected after Marlborough's death, would seem to have given Cobham another idea. Shrewd to the last, he decided in his old age not to leave anything to chance but to set up there and then his own high column of victory, from which, at least in stone, he might live on as lord of all that he surveyed.

1740s

Cobham's pillar, of course, had to outdo Marlborough's, and it did so, being higher by one all-important foot. It also contains a spiral staircase leading to a viewing platform, immediately underneath his larger-than-life image, clad like a Roman general. I once climbed up the pillar one summer evening, after a particularly convivial dinner, and the view, which in those days was not enclosed by glass, was everything Lord Cobham would surely have wished it to be.

Stowe's debt of gratitude to Blenheim was later to be reciprocated when Lancelot Brown, Cobham's head gardener in the 1740s, who had not only directed the pillar's building (1746–49) but adapted James Gibbs' design, later landscaped the Blenheim gardens.

Cobham's monument was an appropriate conclusion to all he had achieved at Stowe. Having inherited 20 acres of gardens, he was to leave 185. And in these he created no less than thirty-six 'temples', the gardens' biggest talking-point. Cobham, maybe, did not have quite the same discrimination as his nephew Earl Temple, and was happy to include Chinese, Egyptian and Gothic buildings among the classical. That, perhaps, was the acquisitive soldier in him, quality occasionally giving way to quantity.

The illustrations show four different moments in the pillar's subsequent history. Top left: as shown in a guidebook of 1776, still without the lion-mounted buttresses (of 1792) which not only gave it greater stability but also improved its looks. Bottom left: as struck by lightning in 1957. Top right: the belvedere, as rebuilt by the school, and topped by a simple fibreglass urn. (Three of the lions, smashed at the same time, were replaced by replicas.) Bottom right: the reappearance of Lord Cobham, the *pièce de resistance* of the National Trust's restoration of 2000–01.

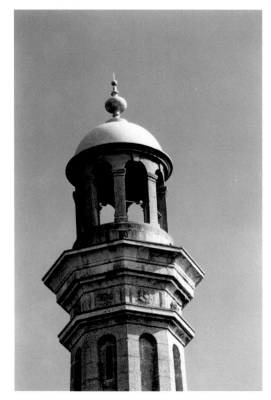

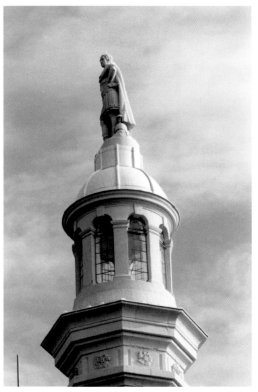

25

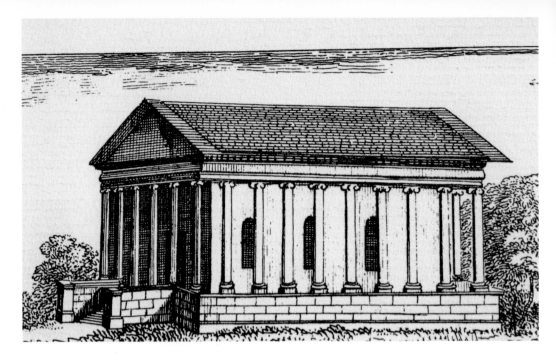

1740s

'Capability' Brown, who developed his landscape gardening skills in his ten successful years at Stowe, was much involved in various naturalisation programmes of the 1740s, including the removal of the parterres. But his greatest legacy was masterminding a 60-acre project turning flat farmland into a deep tree-lined valley, overlooked by an impressive Grecian Temple and hence called the Grecian Valley. Above, Brown's Grecian Temple, to be altered shortly afterwards by Earl Temple. (See p. 32.) Below, a Norfolk terrier is apparently oblivious to the Grecian Valley's attractions.

Earl Temple (1711–79)

Stowe's new owner was the son of Lord Cobham's sister, who had married into the Grenville family. Having inherited several other large estates and having (like his uncle) married an heiress, Earl Temple became one of the richest men in the country. He was also highly-connected, both his brother (George Grenville) and brother-in-law (William Pitt) being Prime Ministers. It was Stowe's good fortune that he matched all these advantages with a strongly developed aesthetic sense, a deep knowledge of architecture and landscape gardening, and enough freedom from politics in his thirty years of ownership to mastermind its cohesive development. By an ongoing process of rebuilding and refining, as lavish as it was inexorable, he created a single, magnificent work of art, in the process turning a rambling country house into a virtual palace.

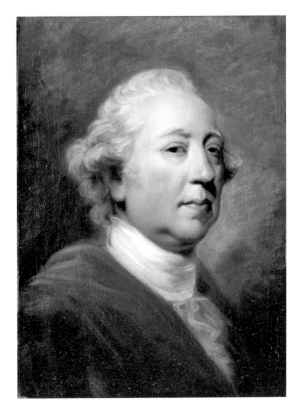

He is thought to have been a very vain man – and the ostentation with which he paraded his Order of the Garter certainly suggests this – yet his letters portray a more rounded personality – strong-minded yet charitable, satirical yet sentimental. Stowe is often mentioned, strongly contrasted to London, that 'abyss of Fog, Sulphur, Fever, cold and all the excretions this side of the Styx'. 'I am extravagantly in love – with Stowe,' he wrote to his sister Hester, William Pitt's wife. 'I relish my Rusticity most exceedingly. Stowe is a Beauty who in her old age grows warmer and warmer ...'

Below, the Prince of Wales, present in 2001 to mark the start of the Stowe House Preservation Trust's first project, photographed before the stunning view to the Corinthian Arch. Of all Earl Temple's achievements, the greatest was surely the magnificence of the South Front and the sweeping landscaped vistas either side of the arch.

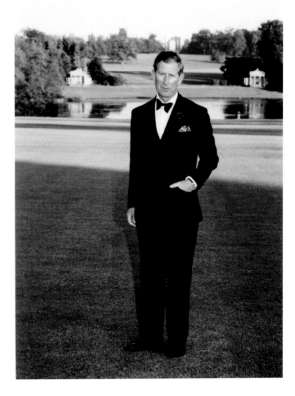

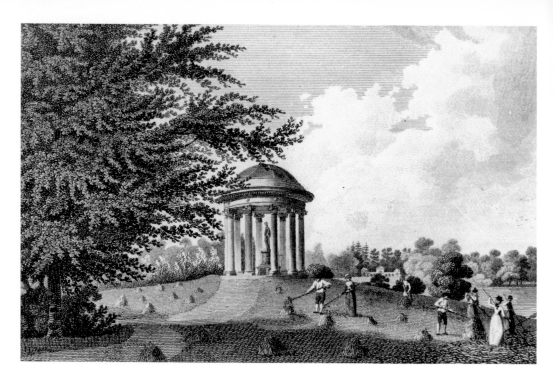

1750s

Earl Temple had learnt much as a young man from a Grand Tour of Italy and France lasting four years. He had also studied Stowe closely as his uncle's intended heir. So on his inheritance, confident in his own judgement, he embarked on a wide programme of tasteful alterations. Vanbrugh's Rotondo, for example, housing a gilt statue of Venus (restored by the National Trust), had suffered from an over-heavy dome which the Earl speedily lightened. As the illustrations show, in its altered state the Rotondo's proportions are perfect.

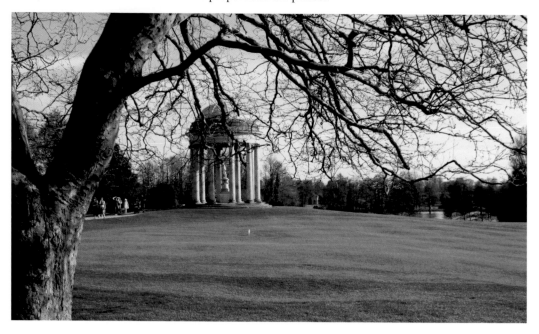

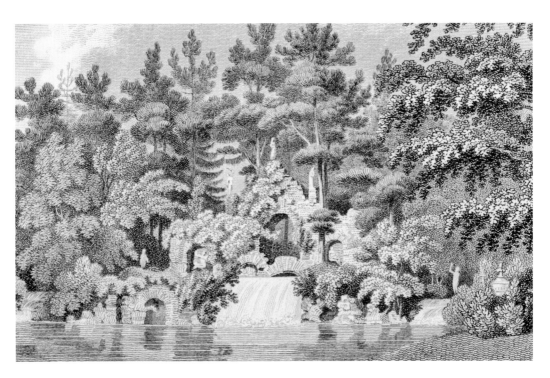

1750s

Earl Temple was forever making changes, and just occasionally, of course, he got things wrong. William Kent had built some simple Artificial Ruins on the narrow strip of land separating the Octagon from the 11-Acre, which, in the early 1750s, Earl Temple embellished with some extra, grandiose statuary. The statues have long since disappeared. The ruins, still with their attractive cascade, probably benefit from being understated.

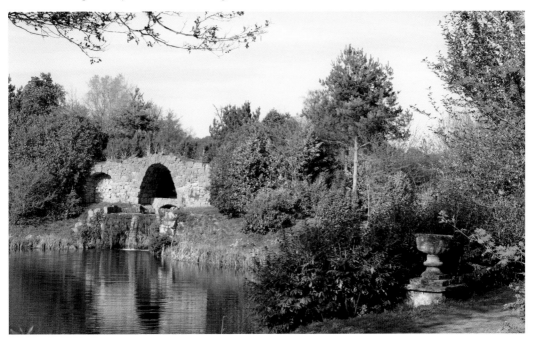

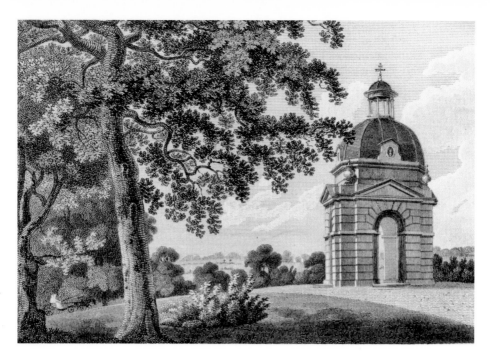

1750s

Another early refinement was the replacement of ungainly pyramid-like roofs of the two Boycott Pavilions (designed by James Gibbs in the 1720s) with graceful domes and cupolas. The East Boycott, illustrated here, was converted by the school in 1954 into living accommodation, something which Lord Cobham had done with the West Boycott 220 years earlier (Lancelot Brown being among its residents). *Inset:* A new cupola in readiness for the East Boycott pavilion, 2011.

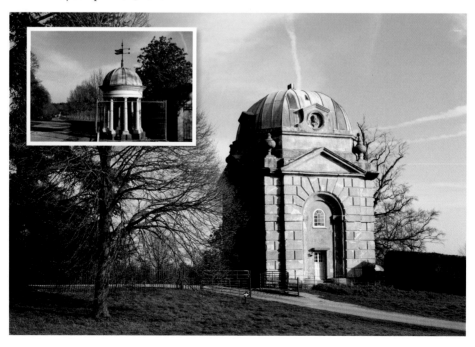

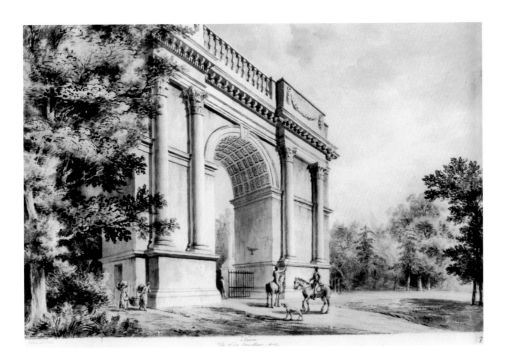

1760s

The Corinthian Arch will always be associated with Earl Temple. The knock-on effect of its landscaping was considerable: on the South Front Sir Richard Temple's avenue of white poplars (planted in 1682) was finally removed; the Octagon was enlarged and naturalised; and the lake pavilions re-sited. The scale of the Earl's landscaping, so much vaster than Cobham's, reflects his personality. Below, a photograph from the bottom of Stowe Avenue, 1977, expressing a centuries-old tranquillity. The new entrance arrangements for National Trust visitors will inevitably bring new levels of traffic ...

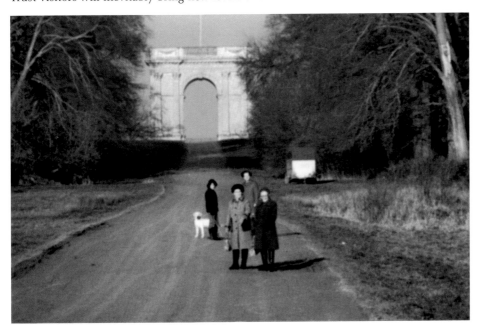

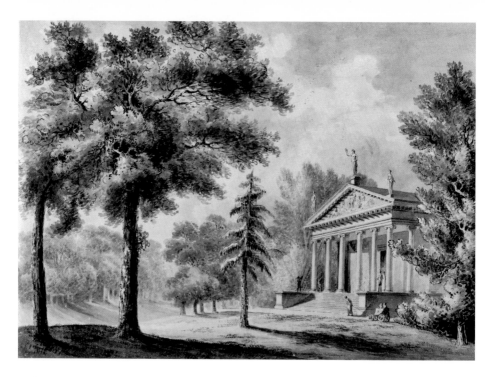

1760s

The Roman-looking Grecian Temple (p. 26) was further Romanised by Earl Temple and dedicated to Concord and Victory, to celebrate William Pitt's successes in the Seven Years' War. A stone relief of the four corners of the world bringing their various products to Britannia (previously on a wall on the Palladian Bridge) was re-located (1761) in the pediment. Below, a pediment detail: a cupid offers a wreath of victory to Britannia. Pitt's Stowe connections are appropriately expressed by the Rotondo (bottom right).

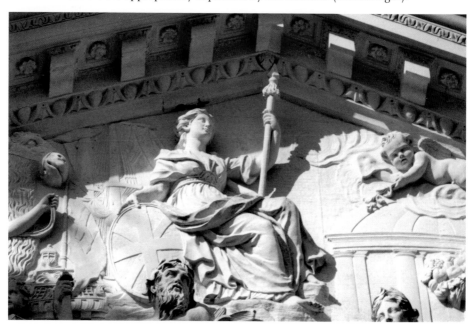

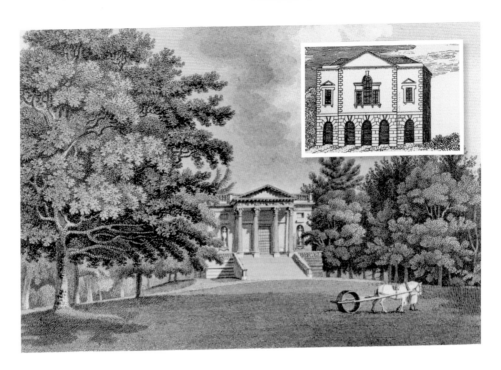

1770s

The Lady's Temple of the late 1740s (inset), which seems to have been 'Capability' Brown's version of an earlier James Gibbs design, was also completely remodelled. Earl Temple's much grander façade, recalling imperial Rome, was probably designed for him by his architect-cousin Thomas Pitt (who would later create the Corinthian Arch). As seen from across the Octagon and Hawkwell Field, it is beautifully contained within its landscape, offering a series of views no painter could easily equal. Below, the start of a girls' inter-house cross-country race, 1999.

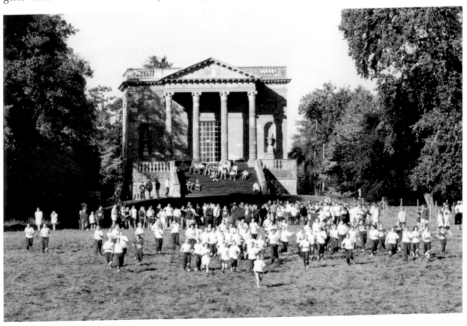

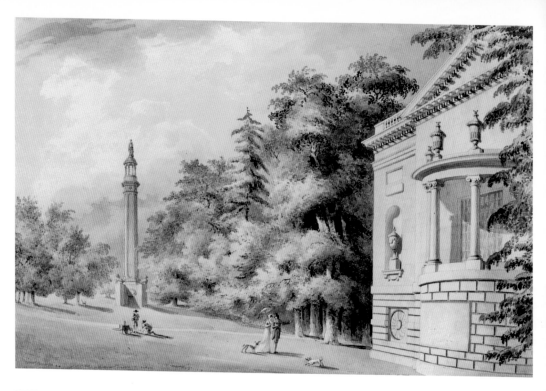

1770s

The north side of the Lady's Temple was also remodelled in the 1770s. By 1805, the date of the drawing above, the building had become the Queen's Temple, renamed and refurbished by the Marquess of Buckingham in honour of George III's wife, Charlotte. The lower window and those down the sides date to 1933, when the school converted the unused ground floor, open to the elements, into a music department.

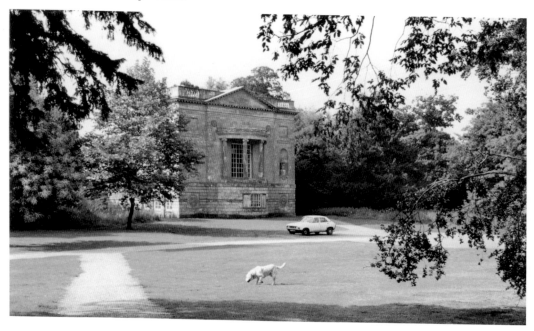

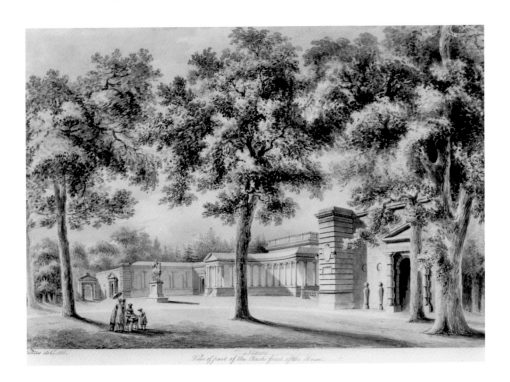

View of part of the Back front of the House.

1770s

In his last years Earl Temple was hugely active, living on a vast building site, as grand state rooms were created and both North and South Fronts achieved resolution. On the North Front (above), nearly 100 years after Sir Richard Temple had started things off, the Earl created new and all-important colonnades. Below, a detail exemplifying the quality of restoration work, an inscription reminding everyone of the Temple-Grenville devotion 'to God, our country and friends'.

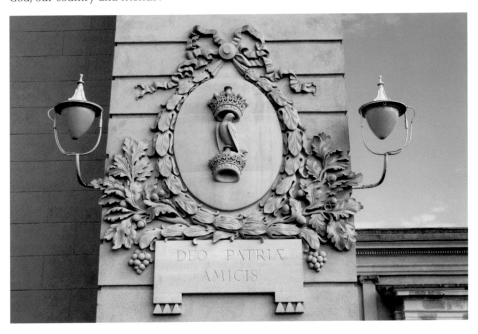

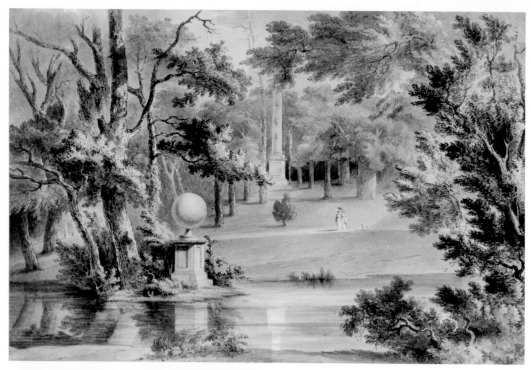

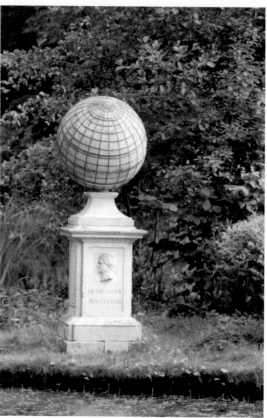

1770s

Earl Temple was also busy in the gardens to the end. As a proud patriot he had commemorated General Wolfe's capture of Quebec with an obelisk (an adaptation of Bridgeman's Guglio). Then, in 1778, he celebrated Captain Cook's explorations in the South Pacific with a monument in a suitably remote location – a small island in the River Styx. The drawing captures the enclosed nature of the Elysian Fields – it is landscape gardening on a particularly intimate scale. The column beyond the path celebrates another seafarer, Captain Thomas Grenville, Earl Temple's brother. Below, Cook's monument, restored to its island in 2002. It had resided many years, without its terrestrial globe, beside a nearby path.

The Marquess of Buckingham (1753–1813)

Expelled from Eton for participating in a riot, Earl Temple's lively nephew redeemed himself by marrying Lady Mary Nugent, who – it almost goes without saying – was an heiress. As a Prime Minister's son, he naturally moved in high circles, but his chief legacy was in seeing through to completion his uncle's glamorous state rooms and exterior façades. Stowe (which he inherited as a twenty-six-year-old) reached the height of social success under him, and there were several new additions, like Soane's Gothic Library. Below, a letter written from Stowe by the Marquess, just four months before his death, in which he declines an invitation to become President of a London Bible Society on the grounds of 'the very infirm state of my health & spirits'.

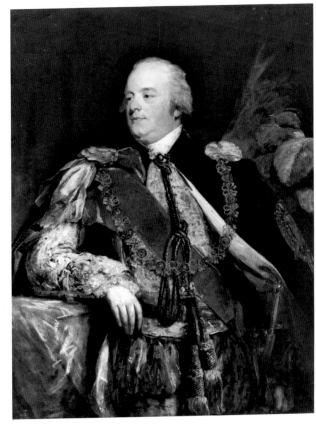

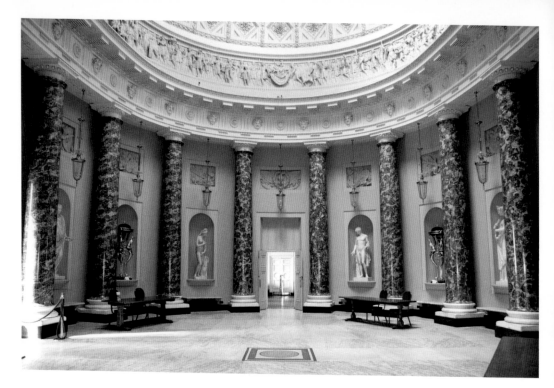

1780s

The Marble Hall after its recent restoration by the Stowe House Preservation Trust is surely looking much as the Marquess would have known it in the late 1780s. Copies of the statues sold in 1848, less than forty years after the Marquess' death, are now back in the niches (see p. 94). Below, there were still empty niches in 2002 at this Common Room reunion, which included biologist John Dobinson, geologist Mike Waldman (with wife Hazel) and Peter Farquhar (English).

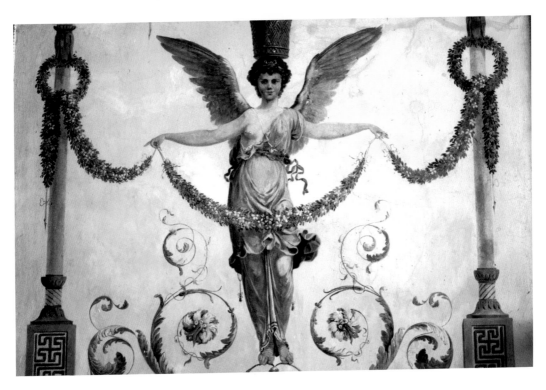

1780s
Above, a detail from Vincenzo Valdre's lovely wall paintings in the Music Room, completed in 1781, executed in the 'grotesque' style inspired by ancient Rome. The Marquess had lingered long at Pompeii on his Grand Tour. Below, a Common Room gathering in the Music Room in the early 1990s featuring long-serving classicist Brian Stephan, whose bust by David Wynne is in the North Hall, and the doyen of domestic bursars, Cyril Atkins.

1780s

Built as a conservatory for the Marchioness, the 'Menagerie' acquired its name in ducal days for the caged animals kept there, though it was as a museum that its contents were sold in 1848, a boa constrictor ('the largest ever seen in this country') selling for 7 guineas and a crocodile for £4 14s 6d. In 1923, it became the school shop. Above, early morning flower-watering, 2011. Below, 'Moss' (William Thomas), who ran the shop for its first twenty years, in pre-war action.

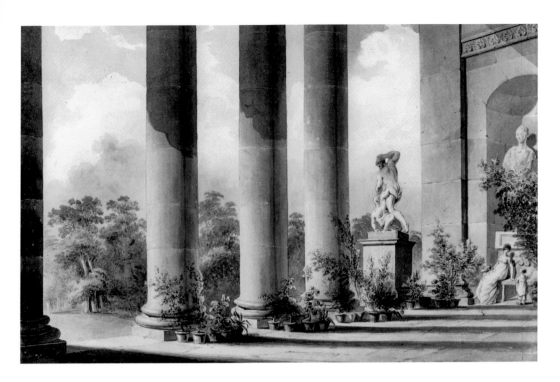

1800s

The Marquess' Stowe was evocatively captured by John Claude Nattes, an artist employed as a resident drawing-master for three summers in the early 1800s. There was tremendous excitement in 1980 when over 100 of his drawings (now in the Buckinghamshire County Museum) came to light. He splendidly catches the calm grandeur of the South Portico. A statue of Hercules wrestling with Antaeus, bought by Lady Glamis for £28 7s 0d, was among several fine classical pieces in the portico at the time of the 1848 sale.

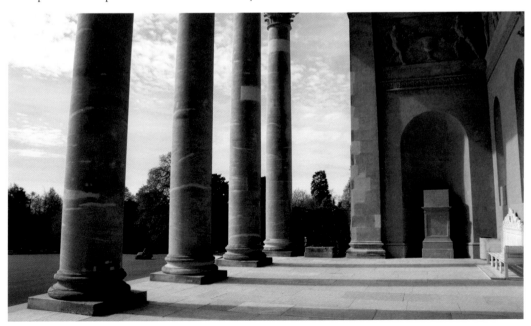

41

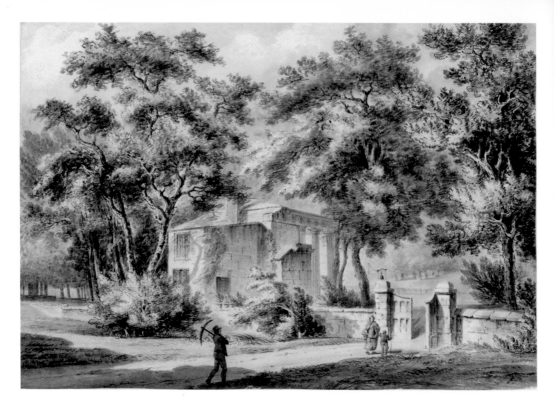

1800s

Nattes' drawing of the Bell Gate entrance to the gardens, beside the East Lake Pavilion. The gate dates to the early 1760s when the pavilions were re-sited and a small lodge was added to create accommodation for the gatekeeper. Below, work in progress, June 2011, for the National Trust's new entry-point to the gardens, just before the opening of the New Inn Visitors' Centre.

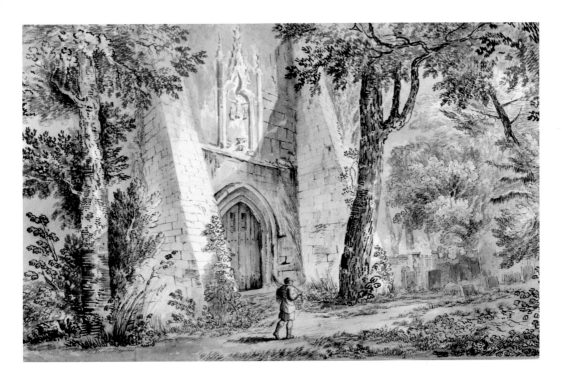

1800s

The west door of Stowe Church in 1807, the second year in which Nattes was employed at Stowe. Alas, it was also the year he was expelled from the Water-Colour Society for exhibiting other people's work as his own. One of the Marquess' many gardeners walks by, a scythe on his shoulder and a strangely modern-looking cap on his head. The two buttresses were fairly recent additions. Below, the Revd Ron Bundock and some of his parishioners, July 2011. (Photograph: Nancy Shepherd)

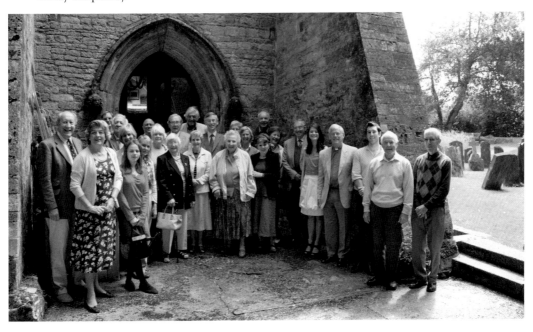

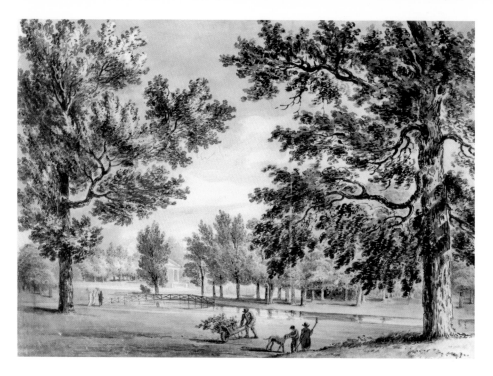

1800s

The figures approaching the wooden bridge are probably friends of the Marquess under the tutelage of John Nattes (1807). In the distance, Vanbrugh's East Lake Pavilion is charmingly framed by trees. Nattes' drawings show the gardens in their heyday, all the eighteenth-century planting having had time to assert itself. Below, the National Trust completing the installation of a copy of the bridge, April 2011. The view is taken from the right-hand river bank, looking down towards the Palladian Bridge.

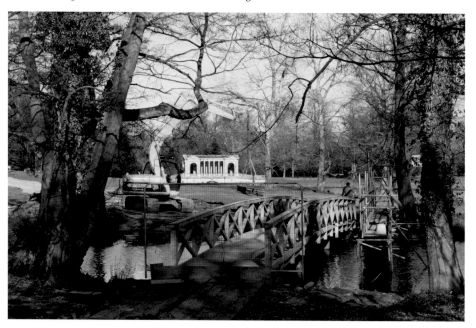

The 1st and 2nd Dukes

An urn of 1839, re-sited in the school's Chapel Court, commemorates the Marquess' son, the 1st Duke of Buckingham and Chandos (1776–1839). Alas, the 1st Duke had proved such a disastrous spendthrift that in 1827 he had fled his accumulating debts (in modern terms perhaps £30 million) and indulged his collector's instincts around the Mediterranean in his newly-built yacht (with a crew of forty-eight), the *Anna Eliza*, acquired on credit and named after the wife he was deserting for new adventures. On his last night before departure from Stowe, after a long drive round the gardens, he loitered 'in silent sorrow' with Anna Eliza among the flowers by the South Front steps, and impetuously presented her with a plucked rose. ('I know that she treasured up the last gift,' he later wrote contentedly.)

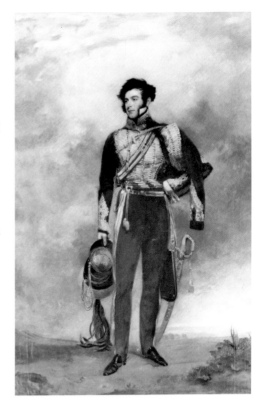

In his own self-deluding way, the Duke had done his best for Stowe, lavishing on the house paintings and antiques he couldn't afford. His garden works included broadening the Octagon, acquiring the nearby Lamport estate, and constructing an attractive alternative approach to the house from the Corinthian Arch to the Boycott pavilions.

John Jackson's portrait (above) of the future 2nd Duke was painted during his father's two-year escape from his creditors on the *Anna Eliza* and seemingly betrays what was to be a fatal flaw – the desire to impress. For all the striking of Byronic poses in the latest uniform of a Colonel of the Hussars (the Buckinghamshire Yeoman Cavalry's regiment), the young man was already running up massive debts. At the time of the portrait he had just saved the Hussars from disbandment by taking over their running costs ...

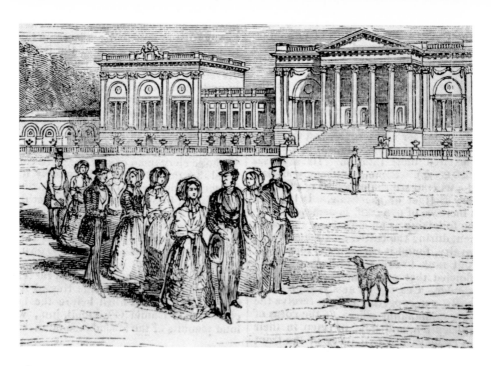

1840s

In 1845, with his finances in ruins, the 2nd Duke (1797–1861) still hosted a three-night visit from Queen Victoria and Prince Albert, a finale of supreme extravagance. Above, the Duke leads Victoria across the South Front (*Pictorial Times*, 18 January 1845). There was much attractive classical detail for the Duke to point out: the mixture of the Corinthian and Ionic orders on the eastern pavilion, for example, and also James Lovell's medallions, and (on the parapet) his figures of Peace and Plenty.

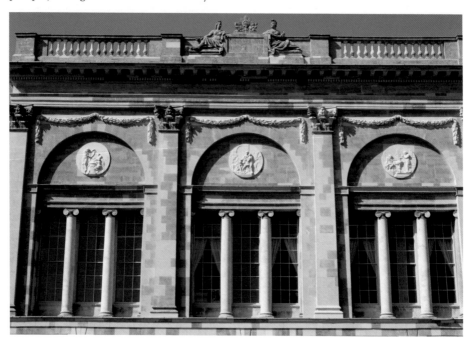

1840s

The press reported the visit fully and respectfully, though the *Pictorial Times* could not help impishly wondering whether it might precipitate a new Temple of Patriotism and Royalty. On the third afternoon Victoria and Albert planted four trees, two either side of the Temple of Concord, the Duke providing a silver-bladed spade complete with crimson velvet handle. Large crowds had been invited from Buckingham to watch. 'Immediately His Royal Highness Prince Albert had planted the last tree, the Duke of Buckingham, waving his hat, cried aloud, "God bless Her Majesty the Queen" and immediately the "welkin rang" with the shouts of the spectators.' Above, Prince Albert and the Duke look on as Victoria plants an oak. Below, the oak today, with the other three trees behind: two cedars and a second oak.

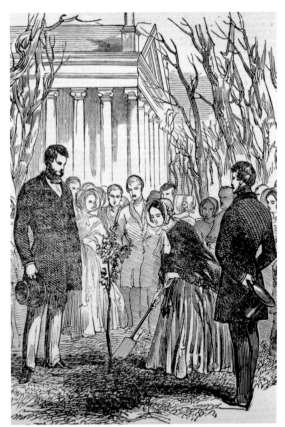

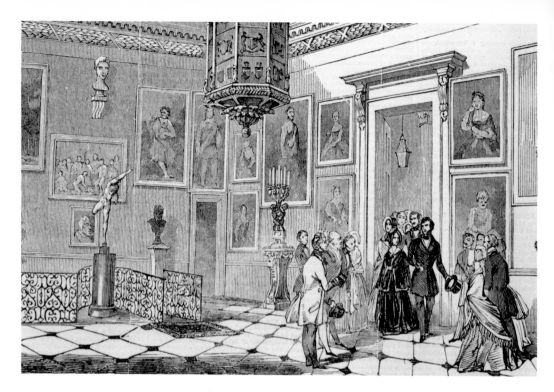

1840s

Finally, at ten o'clock one cold Saturday morning, Victoria and Albert were escorted into the North Hall, prior to departure from the North Front, where 'the whole corps of the Bucks Hussars, except those engaged on escort under the command of Lieutenant-Colonel Bernard' had been waiting for an hour (*Illustrated London News*, 25 January 1845). Victoria, who had not found the Duke agreeable, had heard about his debts and briefly contemplated buying Stowe. Below, a portrait of the 1st Duke dominates the North Hall, 2011.

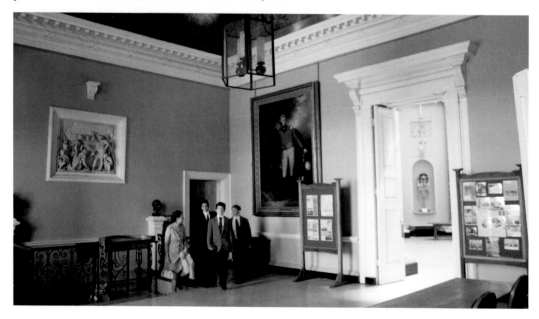

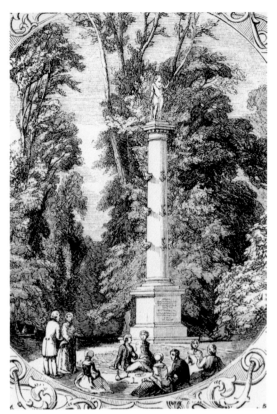

1840s

Bailiffs are said to have been present during the Queen's visit, keeping an eye on things, though dressed as servants. Two years later, in 1847, they broke a window in the North Front door and took over Stowe. The Duke was £100 million in debt. A humiliating forty-day sale of the house's contents followed in 1848, and a 300-page catalogue subsequently chronicled the purchases. Divorced by his wife and dependant on the son he had tried to swindle, the 2nd Duke died in 1861 in a London hotel. Above, an illustration from the catalogue of 1848 of the Grenville Column, celebrating a more honourable moment in the family's history: the death of Earl Temple's brother, killed at sea when fighting for his country.

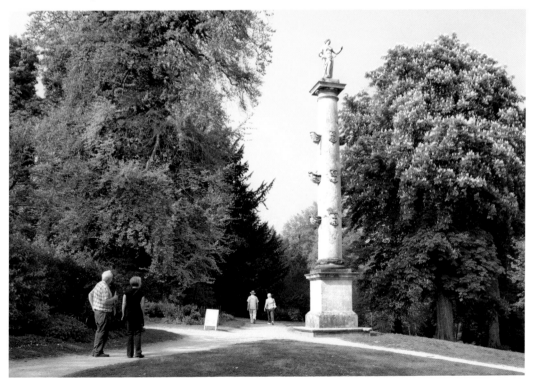

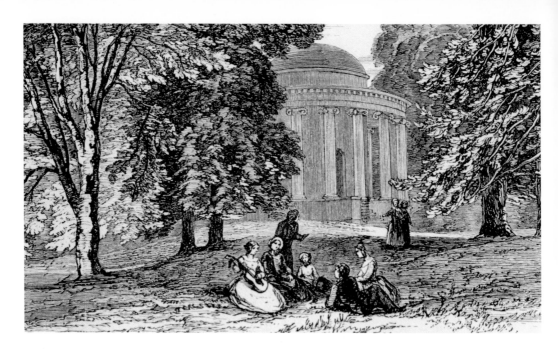

1840s

There was a certain grim irony in the catalogue's inclusion of a drawing of Lord Cobham's Temple of Ancient Virtue, a quality recently not much in evidence. Soon after the sale, the temple was looking badly neglected, with cracks opening up in the walls. One hundred and sixty years later this lovely building has recovered its old glory. Its vulnerable dome is supported by a concrete ring. Its niches once again display Cobham's four exemplary Greeks.

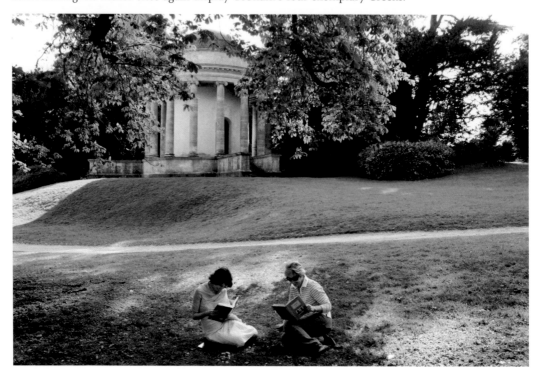

The 3rd Duke (1823–89)

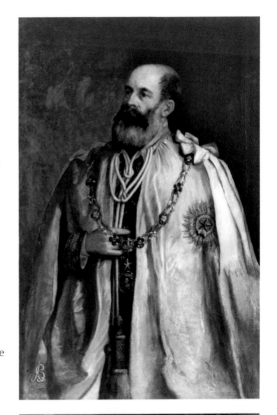

The Duke, painted late in life by his artistic second wife, is wearing the regalia of Knight Grand Commander of the Order of the Star of India, an award from a grateful Queen Victoria for his service as Governor of Madras. But it was his first wife, Caroline Harvey (below), whom he married in 1851, whose financial independence enabled him to take the first important steps in extricating himself from the family's downward spiral. Francis Grant's portrait of her, wearing a glamorous dress and fronting a romantic view of the Corinthian Arch yet with a piece of knitting on her lap, suggests she mixed style with common sense. Was she crucial, perhaps, to the 3rd Duke's success? Certainly by the time he had inherited the empty house, in 1861, and bravely reopened it, the Duke had already proved himself in London, both as an MP and chairman of the burgeoning London and North-West Railway. His friend Disraeli (proposing him to the Queen as Lord-Lieutenant of Buckinghamshire) summed up: 'I remember in the dark troubles of His Grace's youth, telling him that he had a mission to fulfil, and that was to build up again the fortunes of an ancient house. With a steady exercise of some virtues, with the continuous application of a not inconsiderable intelligence, the duke has succeeded in this noble enterprise.' Practical, hard-working and typically Victorian in his delight in innovative machinery – he absolutely loved the railways – the 3rd Duke gave the house an improved water supply, a gas plant and hot-air heating.

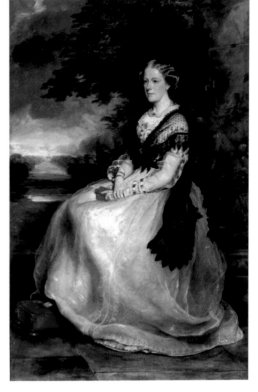

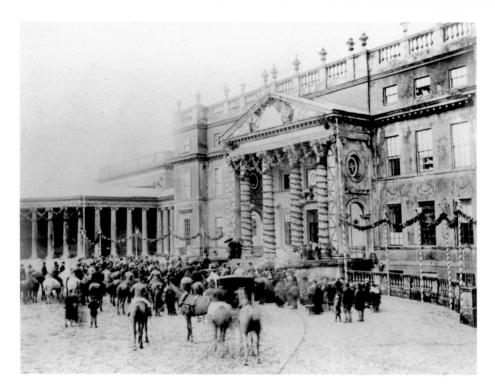

1880s

Many years ago, I chanced upon the photograph above and was so intrigued by the unusual scene that I managed to buy it, though it wasn't for sale. But what was the celebration? The Star of India over the main door suggests it probably represents the 3rd Duke's return (1881) from five years in Madras. Below, the 3rd Duke is seen with his second wife, whom he married in 1885. He had three daughters by his first marriage and no children by the second, so the dukedom died with him in 1889.

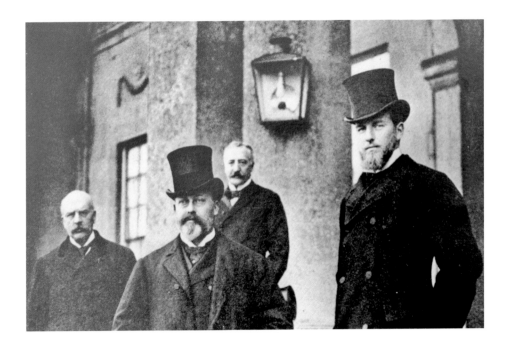

1890s

The Duke's eldest daughter, Lady Kinloss, having unsuccessfully tried to sell Stowe, leased it to the Comte de Paris, the grandson of France's last king, Louis Philippe, and the pretender to the French throne. Above, the Comte de Paris (right, shortly after taking up residence in December 1890) with the Prince of Wales (the future King Edward VII) on the steps of the North Front. Below, another Prince of Wales on the same steps, the future Edward VIII, visiting the school in 1933.

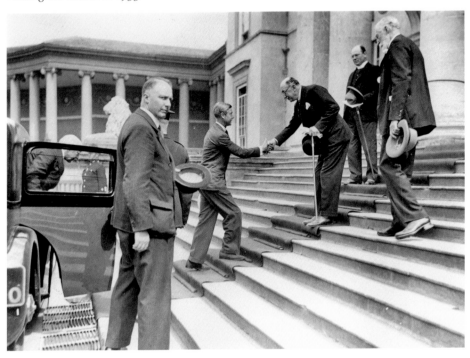

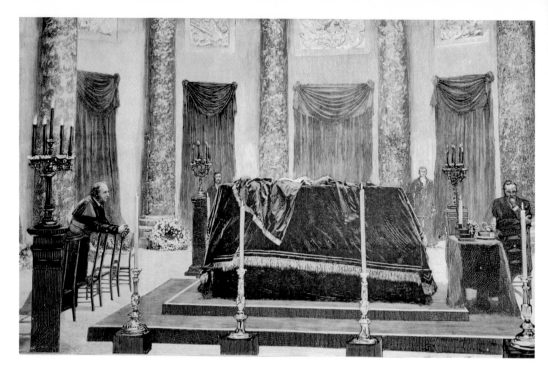

1890s

When the Comte de Paris died at Stowe in September 1894, the Marble Hall was used for a sombre lying-in-state (illustration from *The Graphic*). The popular Comtesse, who had enlivened the neighbourhood with her pack of hounds, finally left Stowe in 1896. Below, the Marble Hall in happier times. A sixth-form English set, led by drama teacher Fiona Baddeley, celebrates National Poetry Day dramatically in the autumn term of 1999.

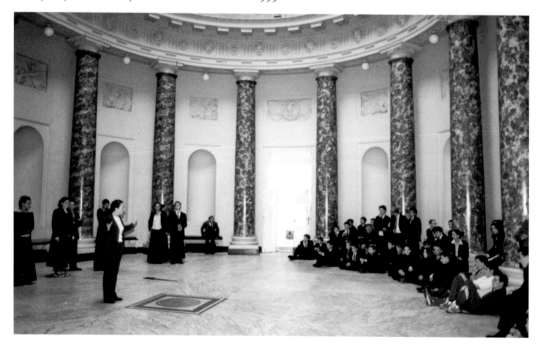

1910s

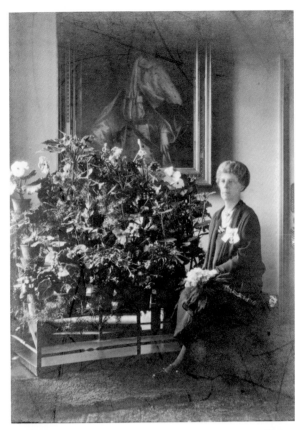

After the departure of the Comtesse, Lady Kinloss (above) returned, as a recent widow, with her five children. There was little heating, but they managed well enough, and in 1905, when King Edward VII and Queen Alexandra were entertained to lunch, memories of the grand days resurfaced. In 1908, there was another big social occasion, the coming-of-age of Lady Kinloss' eldest son, Richard Morgan-Grenville, when 400 tenants lunched in a marquee on the South Front. But in the early months of the First World War Captain Morgan-Grenville was killed in action on the Western Front. Below, a detail from the stained glass window Lady Kinloss gave Stowe Church in his memory.

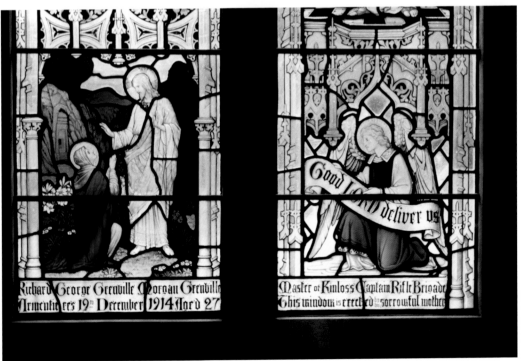

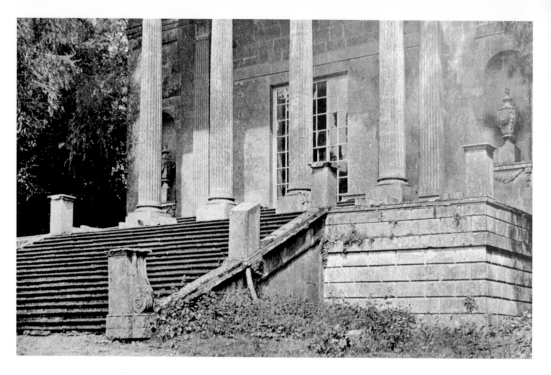

1910s

For 100 years, since the death of the Marquess, Stowe had been in decline, and the gardens reflected this. In the hard-pressed 3rd Duke's time, trees had been cut down for timber. Plantings were random. The temples, too, were dangerously neglected. Above, the Queen's Temple, forlorn in 1914. It was restored by the school in 1932. Below, *Richard III* in 1949, one of the many Shakespearean productions produced at the Queen's Temple between 1935 and 1961 by a dynamic History Tutor, Bill McElwee, and his historians.

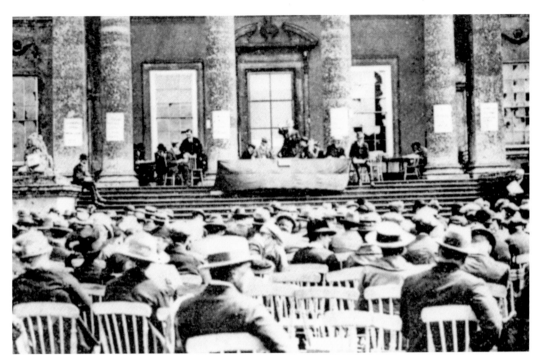

The Arrival of the School

Two auction sales – in July 1921 and October 1922 – preceded the school's foundation. Some years back I came across an account of the first sale in *The Sphere* with this photograph of the opening afternoon's business. The mansion and the immediate grounds ('in a deplorable condition') were offered as a complete lot. 'There were 9 bids in all, so that proceedings lasted but a very short time. Finally the palace was sold for £50,000 with its immediate surroundings, some 272 acres, to Mr Harry Shaw of Beenham Court, Newbury.' By 1923, only six months after the second sale disposed of most of the remaining moveable items, Stowe was being run by a dapper young headmaster, J. F. Roxburgh (seen here with a governor).

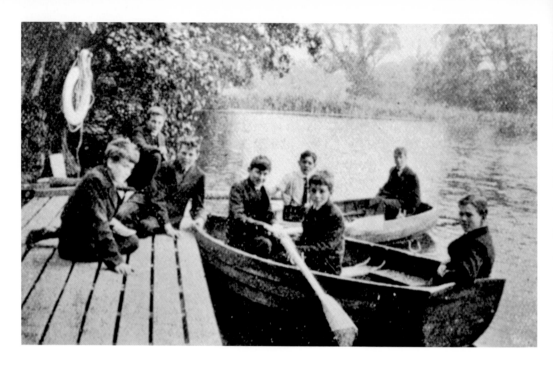

1920s

There were just ninety-nine pupils to begin with, in the summer term of 1923, and a teaching staff of nine. Space abounded, and a sense of unreality must have prevailed. Though *Swallows and Amazons* was yet to be published, this poor but atmospheric photograph exudes the spirit of Arthur Ransome, as eight of the ninety-nine relax at the western end of the 11-Acre, encapsulating the spirit of freedom and adventure which made the young school so very distinctive.

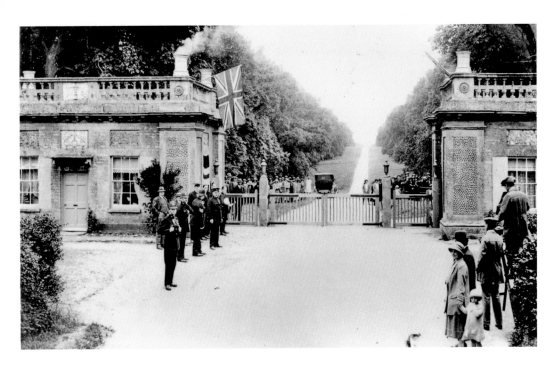

1920s

But for the intervention of Clough Williams-Ellis and the purchase of Stowe Avenue by a group of Old Etonians as a gift to the fledgling school, one of Earl Temple's most striking creations would have been lost to building development. A plaque on one of the Marquess' lodges, celebrating the gift, was unveiled in 1924 by Queen Victoria's grandson, Prince Arthur. Roxburgh (wearing his mortar board) and other school dignitaries are seen awaiting his arrival.

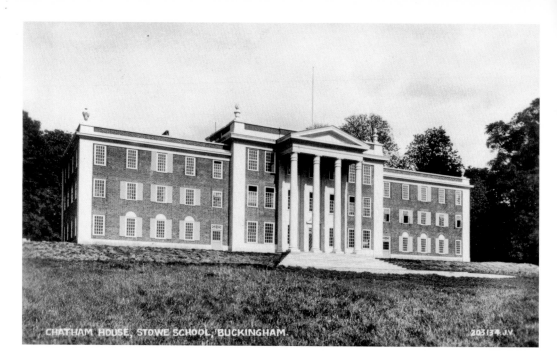

CHATHAM HOUSE, STOWE SCHOOL, BUCKINGHAM. 203134 J.V.

1920s

Clough Williams-Ellis's Chatham (1925), with its fine sweeping views to the Rotondo and the 11-Acre, only had two floors on its wings when first designed (inset). Then extra rooms were deemed necessary. The postcard from the late 1920s shows an integral (but long-lost) part of the designs: green shutters on certain selected windows. The urns on the roof are another lost feature. (They were called back in the early 1990s to resume long-forgotten duties elsewhere ...)

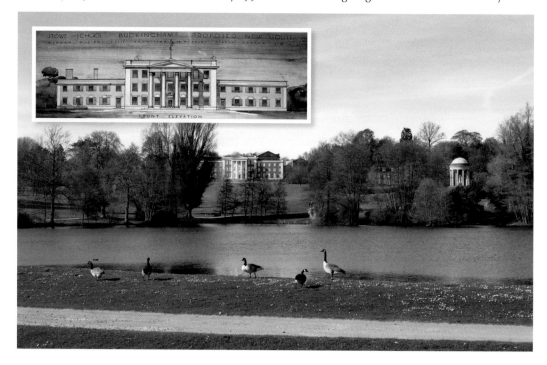

Not all Williams-Ellis' proposals won approval. His chapel lost out to Robert Lorimer's (which used columns removed from the back and sides of the Temple of Concord). He also failed with a bold plan for an assembly hall located across the inside of one of William Kent's arches on the North Front's screen walls. His drawings suggest there would have been an imposing entrance, but blocking the way in to Cobham Court might well have posed problems.

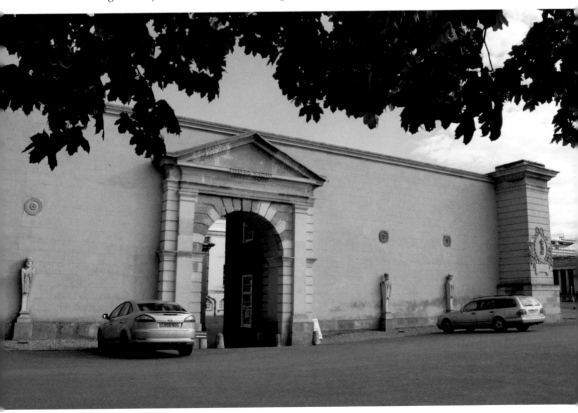

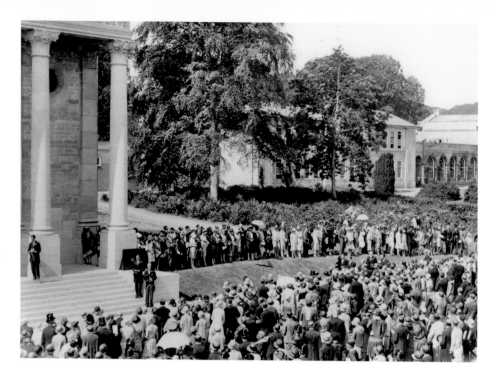

1920s

In 1929, Prince George (later the Duke of Kent) opened Lorimer's Chapel, whose foundation stone his mother, Queen Mary, had laid two years earlier. Seats in chapel, where the glamorous twenty-six-year-old Prince read a lesson, must have been at a premium. Above, crowds in Chapel Court as the royal party approached. *Inset:* The Revd Percy Warrington, Lord Gisborough (the Chairman of the Governors), Prince George and Roxburgh after the service.

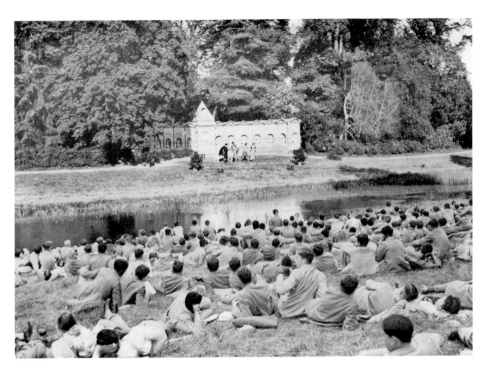

1930s

Above, the whole school watching, with varying degrees of attention, a performance of *Twelfth Night* by the Oxford University Dramatic Society before the Temple of British Worthies, 1931. The previous year the school had used the same setting for a performance of Milton's *Comus*, which every pupil had to study beforehand as well as attend. Musicians played from boats in the river. Lord Cobham's choice of Worthies included both Milton and Shakespeare (below), carved by John Michael Rysbrack.

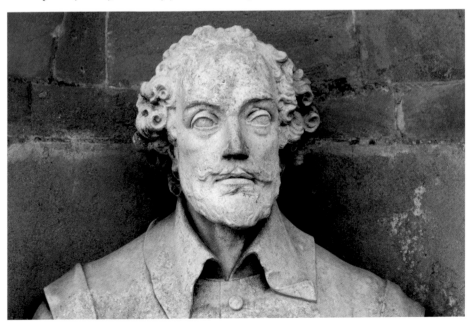

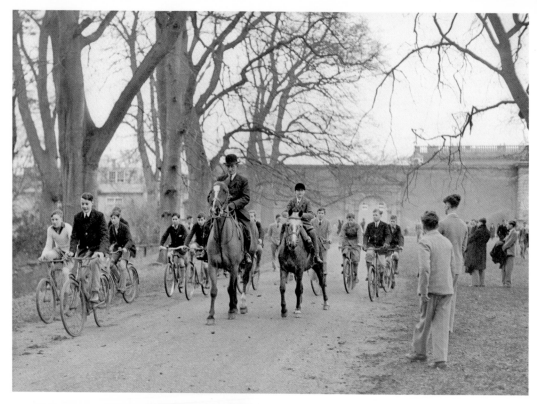

1930s

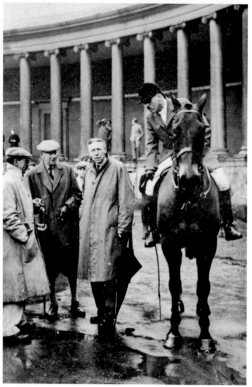

Above, the school's enthusiastic support for the local Grafton Hunt was expressed not just by these cyclists making off in eager pursuit but in the naming of a boarding house. The house (just visible through the trees on the left) was a new building created from an eighteenth-century stable block. Below, Roxburgh with umbrella chatting to the Master of the Grafton, the long-serving Director of Music, Leslie Huggins, *c.* 1947. (Photograph: Mary Connor.) According to legend, Huggins would sometimes play the organ in chapel with a surplice over his hunting kit. The only time Roxburgh returned after retirement was to attend Huggins' funeral, at Stowe Church in 1952.

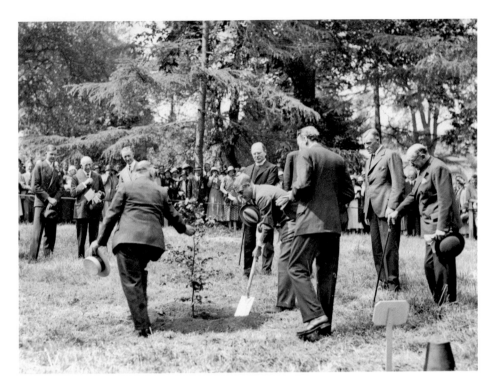

1930s

The school's tenth anniversary, in 1933, was marked by a visit from Edward, the Prince of Wales, who, like his great-grandmother before him, gallantly planted a tree, this time a copper beech, between the church and the South Front. Behind the Prince: Warrington, Ian Clarke (senior housemaster and a keen forester) and Gisborough. Roxburgh watches, back to camera. In 2011, the Prince's tree (right) had a grandstand view of dodgems hired in for the Leavers' Ball.

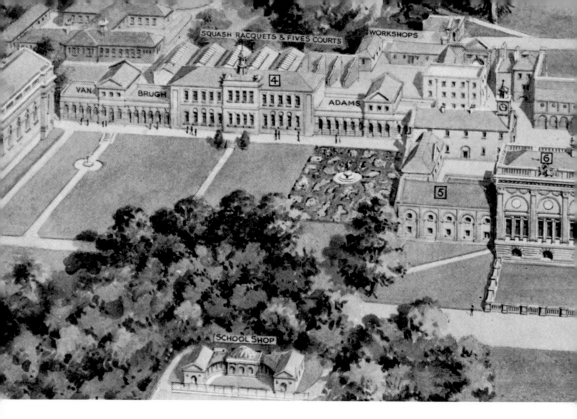

1930s

A bird's-eye view of July 1934 showing the relatively seamless nature of the additions of the previous eleven years. The eighteenth century, in fact, ends with the building marked 'Adams' in the drawing (depicted below in 1805, when it served as an Orangery). Clough Williams-Ellis imaginatively duplicated this building (marked 'Vanbrugh') and linked the two with a central classroom block (4) to create (with Lorimer's Chapel) the graceful Chapel Court.

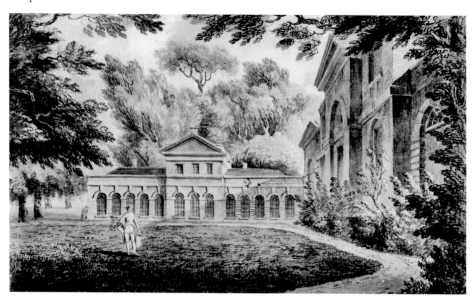

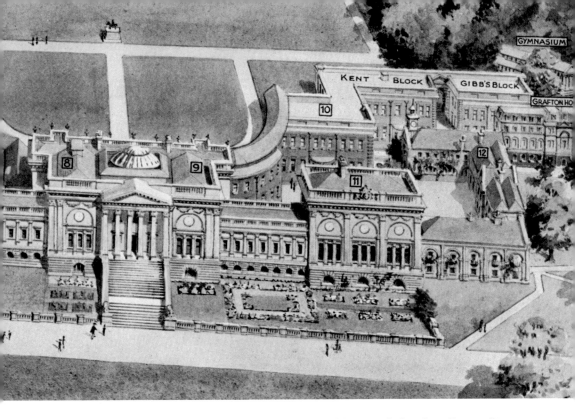

The bird's-eye view also helpfully illustrates red-brick additions of Clough Williams-Ellis – the 'Kent' and 'Gibbs' blocks, which initially served as classrooms. (This was the area where he had originally planned an assembly hall – p. 61). It also shows the flower gardens to the side of the central steps, enclosed by the balustrade put up by the Marquess of Buckingham. Below, Annie Nichols, wife of Headmaster Jeremy Nichols, enlivening an outdoor tea-party, Speech Day 1999.

1930s

Parents and pupils stream away from a function at the old gym, up the Grafton slope to the North Front. The Grafton housemaster's accommodation (to the right, bottom picture) was about to be built. Having decided against Clough Williams-Ellis's hall (p. 61), the school had opted instead for an attractive wooden gym, useful for assemblies, plays and concerts, as a temporary structure to last ten years. It survived into the 1970s.

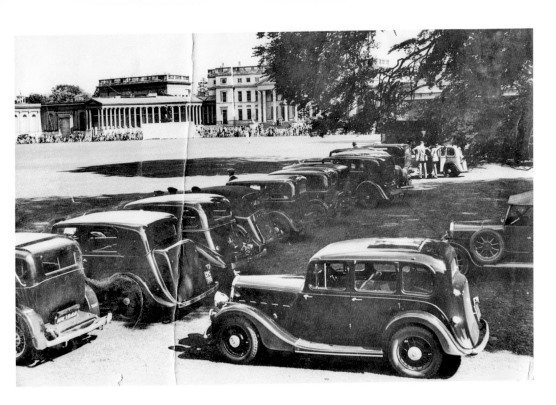

1930s

A rare (though badly creased) photograph of a Speech Day in May 1935 evocatively captures the period. One can almost smell that pungent mix of petrol and leather emanating from all those reassuringly solid limousines. Hoardings protecting the school cricket pavilion from view can just be seen (top right). It was to be opened by former England skipper, Sir Stanley Jackson, two months later. Below, a Colts match against Eton College in 2000, before the North Front restoration.

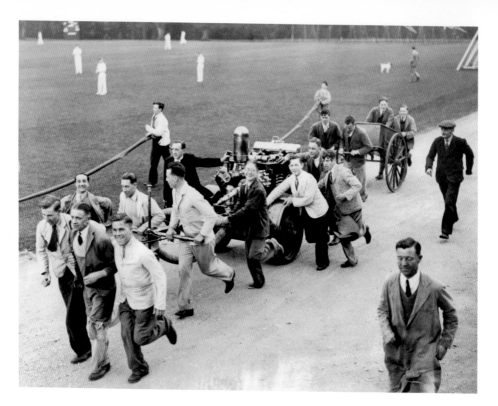

1930s

A recent acquisition via eBay: a French news agency photograph of May 1936. It states that the fire engine (*la nouvelle Moto-Pompe*) is being given its first try-out by Stoics (*élèves dans l'école anglaise de Buckinghamshire*). In fact, it is not *les élèves* doing the hard work, but the domestic staff. (In the background, ignoring all their gallant efforts, a master unconcernedly takes his dog to the cricket.) Seventy-five years on, Buckinghamshire fire officers look somewhat better equipped.

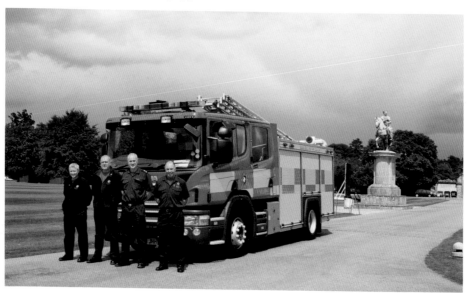

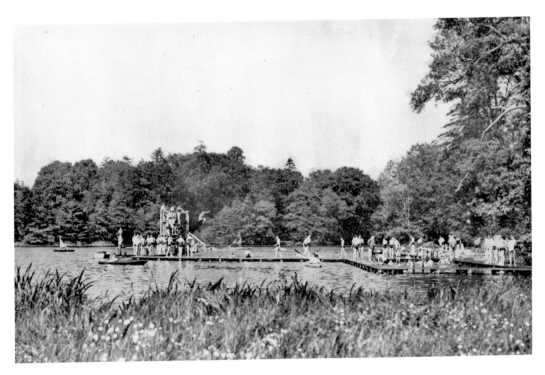

1930s

In the 1920s, pupils could swim in the 11-Acre, near the Temple of Venus, once they had achieved four lengths in a narrow tank situated in the gloomy Power House Yard. In 1931, however, 'a much-desired bathing space was constructed', a gift in memory of an Old Harrovian who had 'been an ardent bather until his 85th year'. Only after an indoor pool was opened (in 1973) was swimming in the lakes abandoned.

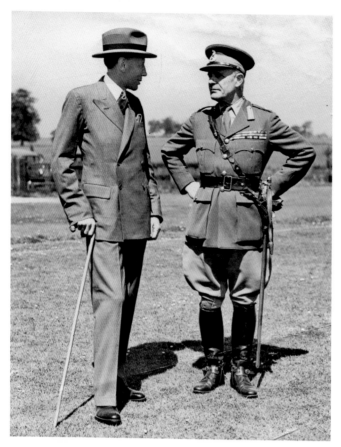

The Second World War
Roxburgh with Lt General Archibald Wavell on the Officer Training Corps' inspection day, 1939. Three months later war broke out. Roxburgh, who had toasted the Munich agreement in champagne, did not share the widespread optimism it would end quickly: 'Hitler may be as mad as you please, but he is not a fool, and he would not have gone in for this war if he had not thought he could win it.' Below, the O.T.C. in the 1920s. Nearly 2,000 former pupils were to fight in the Second World War. Casualties were extremely high. Trying as a Housemaster in the 1980s to make a Remembrance Sunday meaningful, I pinned on the notice-board a house group of the 1930s, marking those killed in the war. It was nearly half of them.

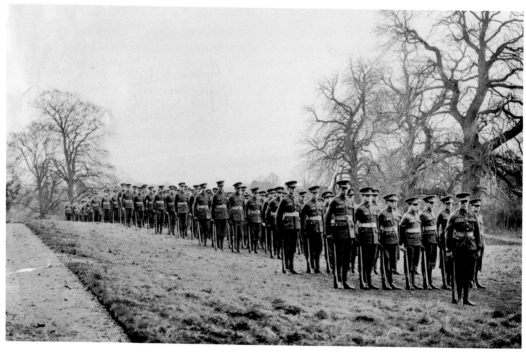

1940s

Just two must represent all that bravery and sacrifice: Marcus Lyon and Leonard Cheshire. Lyon was a typical country-loving pupil, devoted to horses, who helped found the School's riding club. His five years' war service included El Alamein and being parachuted for Special Operations in Nazi-occupied Albania to help lead the resistance. In peacetime, he was a professional artist, though never famous. Leonard Cheshire VC, on the other hand, became a celebrity after his exploits as an airman, and this helped him utilise his peacetime years in the service of the terminally ill and handicapped. Towards the end of his inspiring life he preached, quietly and movingly, in his old school chapel, outside which a bust by sculptor David Wynne (also one of Roxburgh's pupils) was unveiled in 1996.

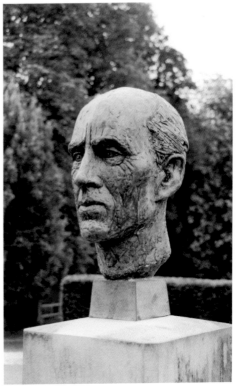

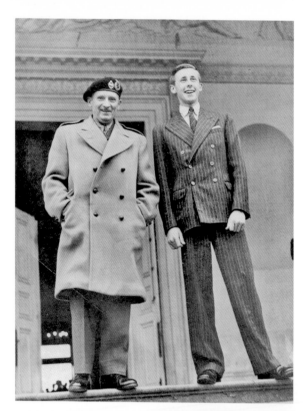

1940s

In October 1945, five months after the war ended in Europe, Field Marshal Viscount Montgomery (seen with the Head of School, above the South Front steps) gave a talk to sixth-formers in the library. The visit of this hugely popular soldier was recorded with some pride: 'After the lecture, Field Marshal Montgomery had tea in the Headmaster's rooms, and before he left the whole School was waiting in Assembly [the Marble Hall] to cheer once more. He spoke again for a few minutes ... After renewed cheering he asked the Headmaster to give the school a whole holiday. The noise from then onwards until his car disappeared in the dark may be left to imagination.' Below, the same setting, sixty-five years into that hard-won peace ...

1950s

William Congreve's monument on Monkey Island, photographed in 1950, suggests the wilder nature of the gardens at this period. Cobham's tribute to his friend and fellow Kit-Cat Club member, erected in 1736, was for many years on an isthmus after the Octagon's enlargement and naturalisation, and only found itself on an island after the 1st Duke's alterations to the lake. In the early 1970s, when I first knew it, the monument could be reached by a rickety single-plank 'bridge'. Today it has become Stowe's Greta Garbo, elusive and mysterious, its monkey still preening itself before a mirror, yet visible only from a distance. A Latin inscription praises the dramatist's 'piercing, elegant, polished wit'. Congreve's scandalous affair with the Duchess of Marlborough would probably have been the talk of Stowe.

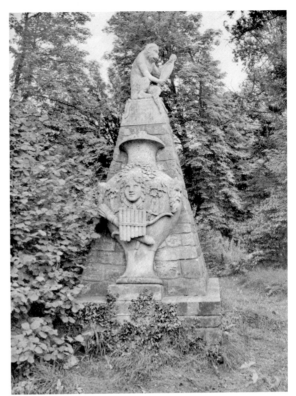

STOWE

A GUIDE TO
THE GARDENS

Rotundo

HO LOVED & CARED FOR THIS CHUR

1950s

In 1956, Stowe's first modern guidebook was published, written by the poet and glass engraver Laurence Whistler, one of Roxburgh's earliest pupils. Although only a small paperback, it nonetheless importantly reflected the school's growing recognition of its responsibilities. 'The renovation of the East Boycott Pavilion is finished,' noted the school magazine that year, 'as is that of the Temple of British Worthies, and work has started on the Temple of Venus. A programme for the care and restoration of William Kent's landscapes has been prepared, and a beginning will be made in the autumn.'

Whistler's lifelong love of Stowe had begun in the 1920s, when his elder brother Rex would often visit: 'He would always drive anywhere where wheels would go, ploughing happily through waist-high bracken and even through undergrowth; and then he would leave the car and walk all round the feature that interested him, or plunge through the elder to some snoring urn I had discovered ...' Laurence's first book of poems, published when still a sixth-former, contained Rex's fanciful, Stowe-inspired line drawings.

The Whistler guidebook is rooted in the 1950s. The cadet force is still using the Gothic Temple as its armoury. The Cobham Pillar is 'unsafe and fenced off'. The removal in the 1920s of Concord's columns for Lorimer's chapel is seen as a 'theft' to be condoned – 'It does even more good to the new building than to the old' – and the tennis courts inserted before Friendship are simply an interesting return from Kent to Bridgeman: 'With their clipped beech hedges they give much of the effect of an irregular, half-formal garden ...'

Below, a window in Stowe Church, engraved by Whistler in 1975, commemorating the 3rd Duke's grand-daughter and depicting Stowe as the gateway to heaven.

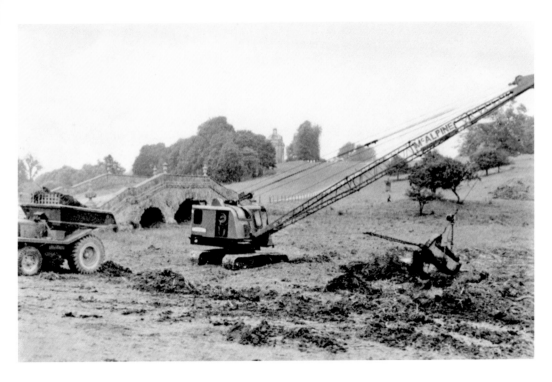

1950s

Early work in the grounds was led by masters like Ian Clarke (commemorated by an avenue of red cedars by the Bourbon Field) and Eddie Capel Cure (whose water garden by the Grotto was, for a time, his memorial). In the 1950s, the Revd Windsor-Richards (nicknamed 'Windy Dick') led the dredging and rebuilding of the Oxford Water, helped by his own engineering training and a useful friendship with the McAlpines. For some time afterwards the Oxford Water was known as 'Lake Windymere'.

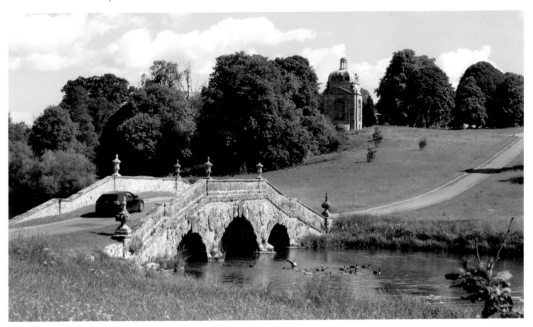

1960s

The proximity of the Temple of Concord to Grafton House has made it an ideal background for the annual photograph. The two centrally seated figures in the group of 1968 are the Housemaster Muir Temple (on the left) and his assistant John Hunt (Roedean's future headmaster). Concord looks fairly forlorn. One end of its bricked-up sides can just be seen to the left. Below, Concord in 1931, headquarters of a flourishing fencing club, inspired by an eccentric but highly accomplished historian, Martin MacLaughlin (centre).

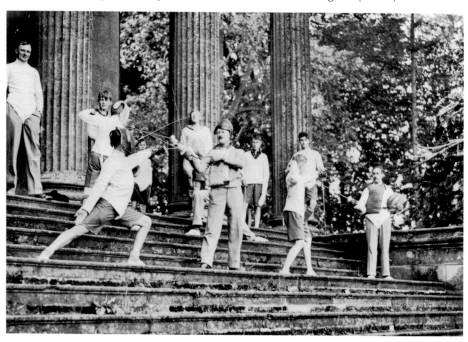

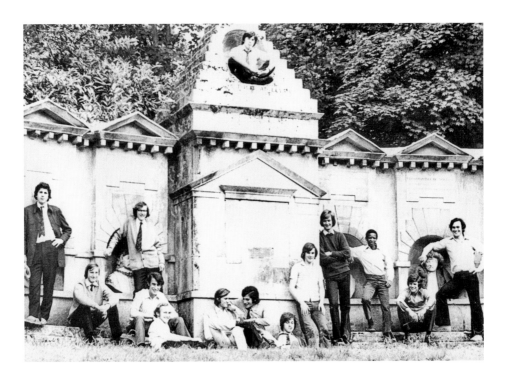

1970s

A group of pupils relax before the Temple of British Worthies in 1972, somewhat unconventionally, exuding that strong sense of fun and self-confidence which generations of Stowe leavers have brought to the outside world. A copy of the head of Mercury (who in classical myth escorted worthy souls across the Styx to the Elysian Fields) was recently installed by the National Trust in the empty central niche. The busts (below) are of Isaac Newton, Francis Bacon, King Alfred and Edward, Prince of Wales.

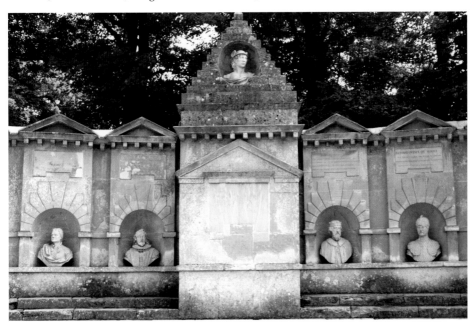

1970s

Outdoor plays continued to be popular in the 1970s and 1980s, but the considerable walk involved in rehearsing the Junior Play of 1974 at the Temple of Friendship (above) made that venue a one-off. The splendid balconies for the Russian and American embassies in Peter Ustinov's *Romanoff and Juliet* (inset) might not have impressed modern health and safety experts. Nor, indeed, all the rockets, fired into the night sky.

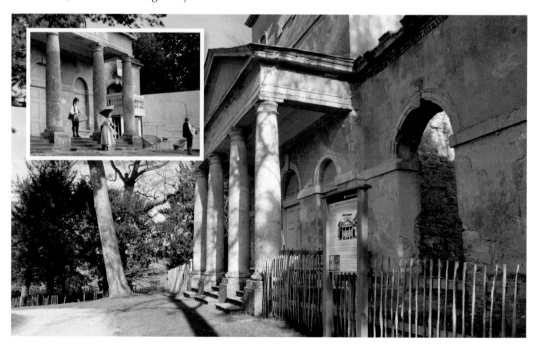

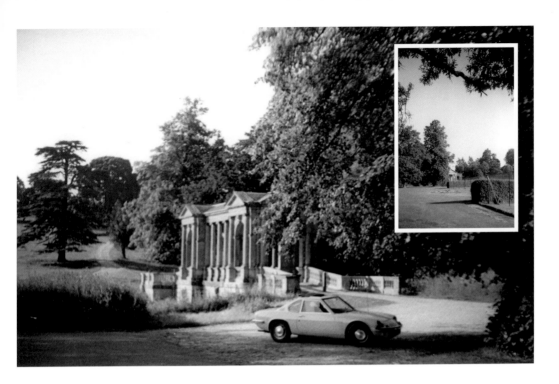

1970S

A sports car parked by Lord Cobham's Palladian Bridge in 1974 suggests that a master was on Palladian Tennis Court duty. (The terraced courts were cleared away in the 1990s, tennis moving to a less intrusive site.) The view to the Gothic Temple has not much altered, but the view back to the Temple of Friendship (inset) is now less cluttered.

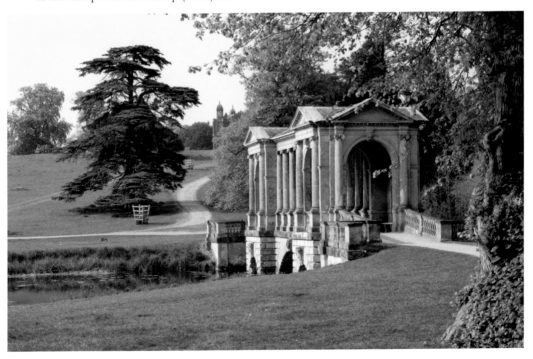

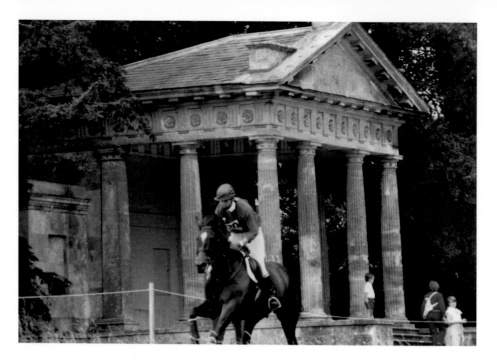

1980s

Above, a competitor at the Stowe Horse Trials of 1985 passing the East Lake Pavilion, four years before the National Trust took over the grounds. Below, the well restored building, about twenty-five years on. The dog is a reminder of the pavilion's lost murals (painted for Cobham in the 1730s by an Italian, Francesco Sleter) – scenes of Arcadian romance from Handel's opera *The Faithful Shepherd*, in one of which Dorinda was pining for the dog-obsessed hunter Silvio.

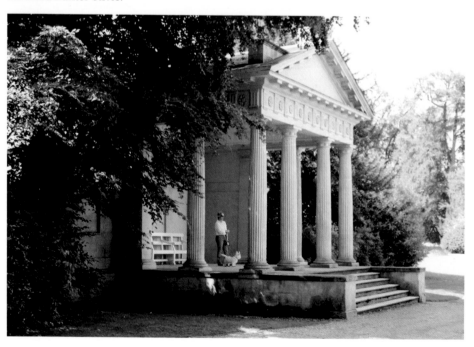

1990s

The steady renaissance of the gardens under the National Trust coincided with an initiative within the school to derive greater educational value from house and grounds. A Project in Visual Education was accordingly developed, seeking to enable pupils in later life to respond to the built environment in an informed way. Its premise – that the classical tradition makes an admirable starting-point for analysis of contemporary trends – meant that not only was Stowe's architectural heritage to be explored in some detail but also continually related to the outside world. Above, a Visual Education student meets the Emperor Vespasian at the Temple of Venus. Below, the use of audio-tapes in both house and grounds soon became an integral feature of the courses.

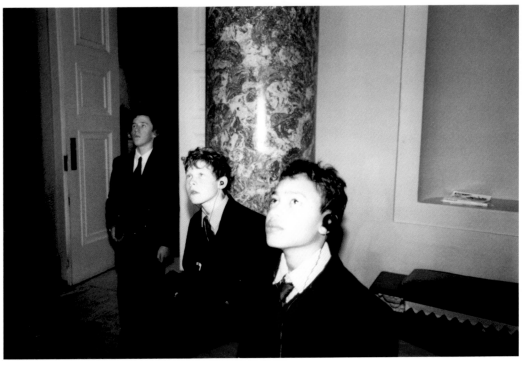

1990s

The circle of Saxon Deities is a typical National Trust success story. All seven statues by Rysbrack (one for each day of the week) had been sold in 1922, but by the late 1990s (above) the National Trust had re-established two copies of the originals. (The originals would have been hard to acquire. Two recently came up for auction, each with an estimate of over £200,000.) Below, Se Sunna (Sunday), one of the first two returnees, now pleasantly weathered and enclosed within matured planting.

2000s

Beautifully restored in 2002, the Fane of Pastoral Poetry is a powerful spokesman for the classical ideals underpinning the Stowe Landscape Gardens. One of the remoter, less ostentatious temples, lying in the woods of 'Capability' Brown's Grecian Valley, it salutes the never-never land of Arcadia, an idealised countryside whose tranquillity and beauty were once memorably celebrated by poets of classical antiquity. Earl Temple, who created this charming tribute to the pastoral ideal from materials provided by his uncle, would have been as well versed in poets like Virgil and Theocritus as he was familiar with the pastoral murals on the Lake Pavilions and Cobham's statues of shepherds and shepherdesses, some of which he moved to a nearby grove, to create a circle around a statue of a dancing faun ...

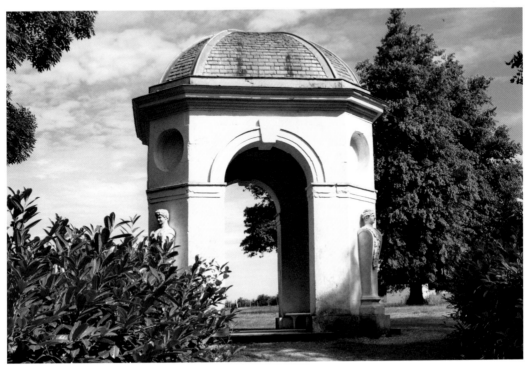

2000s

Just months before the restoration work on the North Front began, the west colonnades were looking particularly gloomy behind cheerful modern linguist Emma Morton. Below, today, nearly ten years after restoration, the colonnades still appear very spruce. Whereas in the previous re-stuccoing of the 1860s and the 1920s a sand and cement render had been used which was liable to cracking and damage from frozen rain water, in 2000–02 a lime render was employed from which moisture can evaporate.

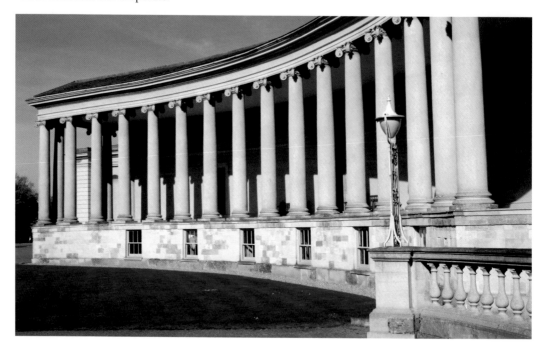

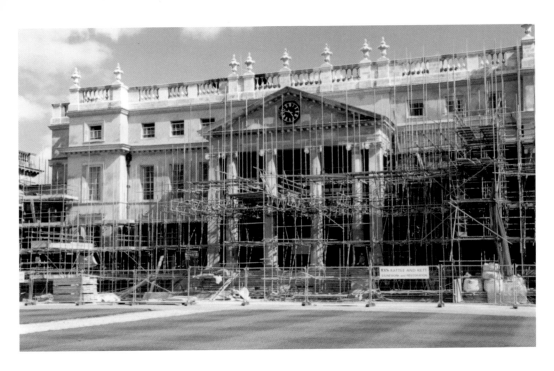

2000S

It was an exciting moment when the scaffolding came down from the central pavilion, five years after the Stowe House Preservation Trust was formed and over two years after phase one work began. Particularly noticeable were the splendid urns on the roof, their predecessors having been removed on safety grounds. Below, Speech Day, 1933. Although the fencing catches the eye, the improved state of the stucco is also impressive. (Compare p. 13.)

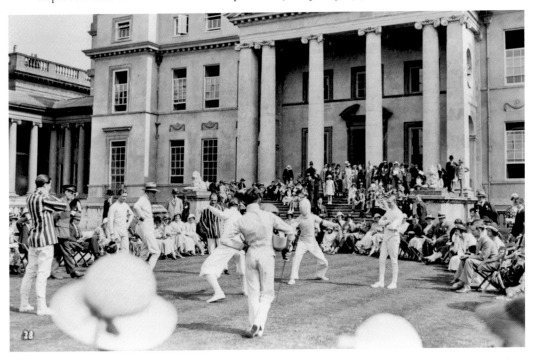

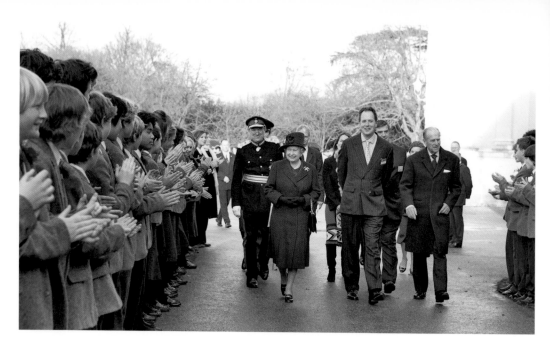

2000S

The Queen and Prince Philip, escorted by Headmaster Anthony Wallersteiner, just after their arrival by helicopter on the North Front, November 2007. Later in the day the Queen opened the first of two new girls' boarding houses designed by Rick Mather, appropriately called Queen's. (Full coeducation was introduced in 2003.) Eighty years earlier her grandmother Queen Mary (below, escorted on the South Front by J. F. Roxburgh) had laid the foundation stone of the chapel.

2000S

Above, the two buildings opened on those respective royal visits: Queen's House (left) and the chapel (right). Between them lie Bruce House (1985) and the Art School of 1935, reconstructed by Rick Mather in 2010. There is a remarkable harmony, for all the stylistic contrasts, Queen's being a clear indication of the pleasing coherence the new development plan will bring the scholastic area. Below, Vanbrugh's Temple of Bacchus on the same site, 1797. In need of expensive restoration, it was dismantled in 1926 to make way for the chapel.

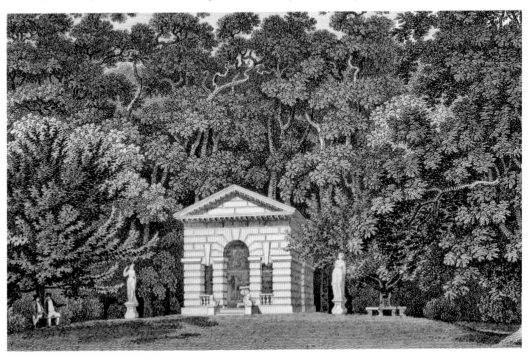

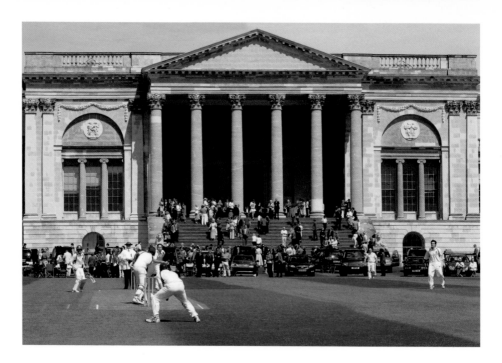

2000S

By 2006, restoration was complete on the central pavilion, shown above, looking lofty and serene as usual, though competing for attention with a Speech Day cricket match, 2009. (The lofty serenity is partly created by the exclusion of south-facing windows on the upper floors.) Below, the South Front similarly under competition on the Speech Day of 1949, when formal thanks were being paid to Roxburgh on his retirement. The clock being presented by former pupil John Boyd-Carpenter MP copied the chimes of that on the North Front.

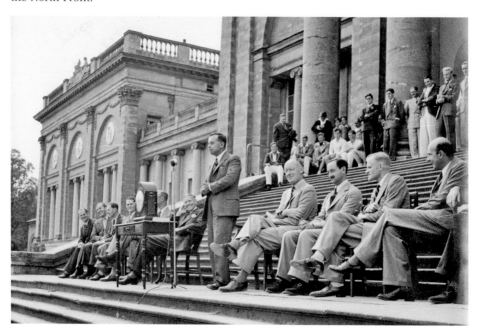

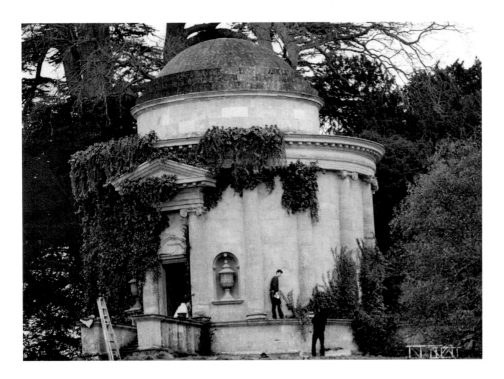

2000S

Final adjustments being made, before filming, to the Temple of Ancient Virtue, temporarily transformed into a mausoleum for *The Wolfman* (2009), starring Benicio Del Toro and Anthony Hopkins. Its interior, being too confined a space, was recreated in a studio. Stowe has attracted many film-makers over the years. One bizarre night in the summer holidays of 1988 (below), Steven Spielberg directed sequences for *Indiana Jones and the Last Crusade* from a high perch on the North Front. Here the Nazis are busy burning books.

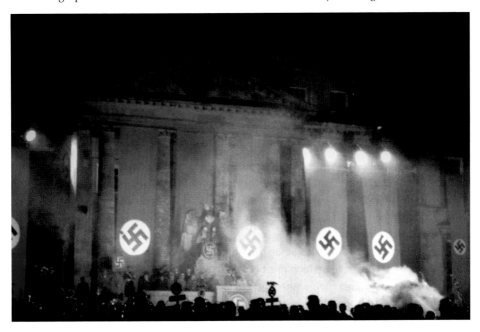

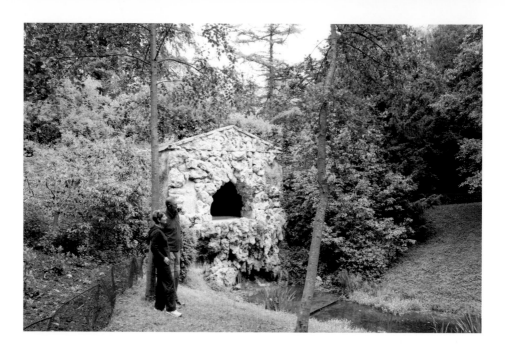

2010S

The Grotto's recent restoration includes a statue of the Crouching Venus (sold in 1848 for 16 guineas) in a marble basin, a restored water flow, via another larger marble basin, to the river below, and a floor of 70,000 pebbles, painstakingly laid by hand. The new exterior tufa is a reminder that, though originating in the late 1730s, the Grotto was reworked in the Marquess of Buckingham's time, reflecting his taste in the Picturesque, the first stirrings of the Romantic movement (well captured in Nattes' drawing).

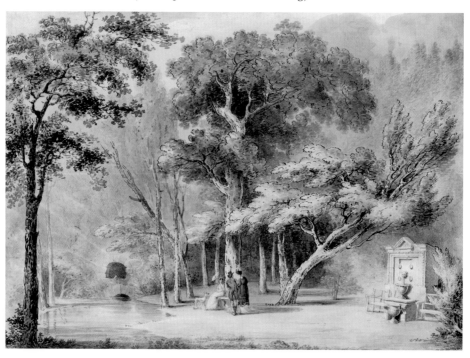

2010s

Two decades of National Trust achievement culminated in the creation of a spacious new Visitors' Centre by the Corinthian Arch in 2011. Understandably it is the big projects, like this, which make the headlines. Less spectacular, though nonetheless very important, are the unremitting programmes of clearance and re-planting, often with posses of valiant volunteers. The new planting in the Grecian Valley's woods, for example, has matured significantly in just ten years.

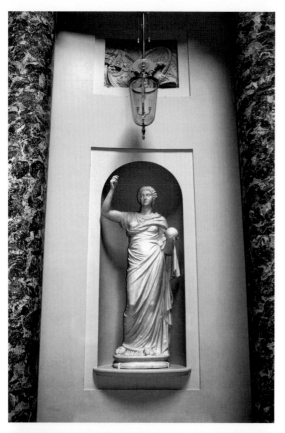

2010S

That the muse of astronomy, Urania, was in a Marble Hall niche, posing with dignity for *Stowe Through Time*, was thanks to a generous private initiative which allowed the Preservation Trust to extend its second phase to include the restoration of the Marble Hall. It made good sense to do so, as this phase already had a direct bearing on the Marble Hall in the re-roofing of the central pavilion, the renewal of the Marble Hall's supporting structure and the removal of old water tanks above its plastered dome. A project of great intricacy which took over three years to complete (2003–06), it included the introduction of specialised lighting and heating; repairs to all the delicate plasterwork, the scagliola columns and the marble floor; and the replacement of missing sculpture.

The niches, empty throughout the school's history, have always been an attraction to the imaginative. Somewhere, it is said, a photograph exists of the Beatles posing in them when visiting Stowe for their concert in the Roxburgh Hall. And in the late 1980s sixth-former Kate Reardon found the Marble Hall an ideal place to model an A-level Design project. (Photograph: Alex Eve.) It was an auspicious occasion, too, for soon afterwards she had embarked on her distinguished career in fashion. She is the current editor of *Tatler*.

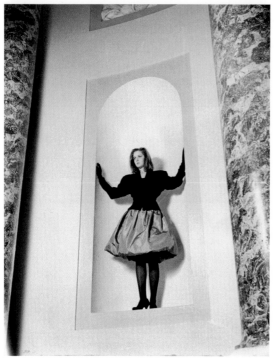

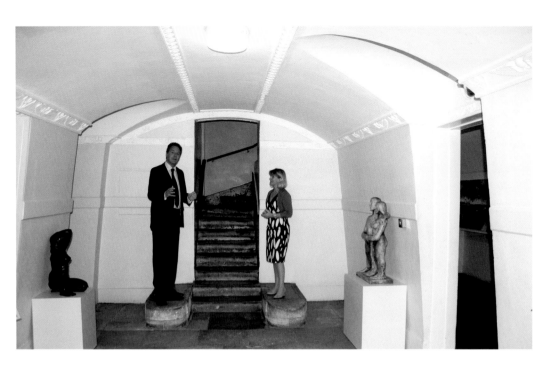

2010s

So, much is happening. Indeed, there's unprecedented excitement in the air, for all three partners have such ambitious agendas. As the National Trust prepares for the opening of the New Inn Visitors' Centre and the school looks to its first completely purpose-built Music School, the Preservation Trust plans the revitalisation of the Marquess' Egyptian Entry. Above, Headmaster Anthony Wallersteiner discusses sphinxes in the Egyptian Entry with his marketing manager. Below, the sphinxes in Nattes' view of 1805.

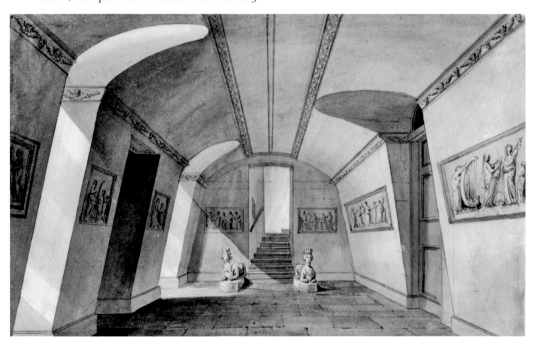

One of the Stowe House Preservation Trust's latest achievements has been the restoration of the Marquess of Buckingham's library. 'The ceiling is most richly decorated,' commented a guidebook back in the 1st Duke's time. As recently restored, it is rich indeed.

Acknowledgements

Many thanks to Michael Bevington, who has kindly supplied various scans and most speedily answered various requests; grateful thanks, too, to Kathy Campbell of the school's marketing department for several photographs; F. F. Bray, F. F. Scott, W. M. Howes, and F. F. Simons of the Buckinghamshire Fire Service; the Buckinghamshire County Museum Collections (for permission to reproduce Nattes' drawings (pp. 10, 31, 34, 35, 36, 41, 42, 44, 66, 92 and 95) and Stowe School for permission to reproduce those on pp. 22, 32 and 43; R. & H. Chapman for p. 56 (below) and p. 78 (above); the Royal Commission on the Historical Monuments of England for p. 12 (above); and to Emily Cherrington, Colin Dudgeon, Sarah Flight, Anna McEvoy, Heather, Anna and Michael Meredith, Nick Morris, Joe Pettican, Crispin Robinson, Nancy and Robin Shepherd, Muir Temple, Dr Anthony Wallersteiner, Caroline Whitlock, Susie Wigginton and Dr Manon Williams.